Why It's OK
to Enjoy the Work of Immoral Artists

The #metoo movement has forced many fans to consider
what they should do when they learn that a beloved artist has
acted immorally. One natural thought is that fans ought to
give up the artworks of immoral artists. In *Why It's OK to Enjoy
the Work of Immoral Artists*, Mary Beth Willard argues for a more
nuanced view. Enjoying art is part of a well-lived life, so we
need good reasons to give it up.

And it turns out good reasons are hard to find. Willard shows
that it's reasonable to believe that most boycotts of artists won't
succeed, so most of the time there's no ethical reason to join in.
Someone who manages to separate the art from th⸺ ˙ist isn't
making an ethical mistake by buvin⸺ rt. She
then considers the eth˙ s and
the so-called "cancel cu cally
risky because it encoura⸺ :on-
cludes by arguing that t⸺ ⸺ooked the
power of art to change ou ⸺⸺ good.

It's of course OK to decide to give up the artwork of
immoral artists, but – as Willard shows in this provocative
little volume – it's OK to continue to enjoy their art as well.

Mary Beth Willard is an Associate Professor of Philosophy at
Weber State University in Ogden, Utah. She received her Ph.D.
from Yale University and writes primarily on topics in aes-
thetics and blogs at aestheticsforbirds.com.

Why It's OK: The Ethics and Aesthetics of How We Live

About the series:

Philosophers often build cogent arguments for unpopular positions. Recent examples include cases against marriage and pregnancy, for treating animals as our equals, and dismissing some popular art as aesthetically inferior. What philosophers have done less often is to offer compelling arguments for widespread and established human behavior, like getting married, having children, eating animals, and going to the movies. But if one role for philosophy is to help us reflect on our lives and build sound justifications for our beliefs and actions, it seems odd that philosophers would neglect arguments for the lifestyles most people – including many philosophers – actually lead. Unfortunately, philosophers' inattention to normalcy has meant that the ways of life that define our modern societies have gone largely without defense, even as whole literatures have emerged to condemn them.

Why It's OK: The Ethics and Aesthetics of How We Live seeks to remedy that. It's a series of books that provide accessible, sound, and often new and creative arguments for widespread ethical and aesthetic values. Made up of short volumes that assume no previous knowledge of philosophy from the reader, the series recognizes that philosophy is just as important for understanding what we already believe as it is for criticizing the status quo. The series isn't meant to make us complacent about what we value; rather, it helps and challenges us to think more deeply about the values that give our daily lives meaning.

Titles in Series:

Why It's OK to Want to Be Rich

Jason Brennan

Why It's OK to Be of Two Minds

Jennifer Church

Why It's OK to Ignore Politics

Christopher Freiman

Why It's OK to Make Bad Choices

William Glod

Why It's OK to Enjoy the Work of Immoral Artists

Mary Beth Willard

Why It's OK to Speak Your Mind

Hrishikesh Joshi

Selected Forthcoming Titles:

Why It's OK to Get Married

Christie J. Hartley

Why It's OK to Love Bad Movies

Matthew Strohl

Why It's OK to Eat Meat

Dan C. Shahar

Why It's OK to Mind Your Own Business

Justin Tosi and Brandon Warmke

Why It's OK to Be Fat

Rekha Nath

For further information about this series, please visit:
www.routledge.com/Why-Its-OK/book-series/WIOK

MARY BETH WILLARD

Why It's OK
to Enjoy the Work of
Immoral Artists

Routledge
Taylor & Francis Group

NEW YORK AND LONDON

First published 2021
by Routledge
52 Vanderbilt Avenue, New York, NY 10017

and by Routledge
2 Park Square, Milton Park, Abingdon, Oxon, OX14 4RN

Routledge is an imprint of the Taylor & Francis Group, an informa business

© 2021 Taylor & Francis

The right of Mary Beth Willard to be identified as author of this work has been asserted by her in accordance with sections 77 and 78 of the Copyright, Designs and Patents Act 1988.

Library of Congress Cataloging-in-Publication Data
A catalog record for this title has been requested

ISBN: 978-0-367-89865-6 (hbk)
ISBN: 978-0-367-89864-9 (pbk)
ISBN: 978-1-003-02155-1 (ebk)

Typeset in Joanna MT and DIN
by Deanta Global Publishing Services, Chennai, India

Contents

One

I.

When my children were small, well-meaning relatives who loved them very much gave them a number of musical toys, which invariably tinkled tinny tunes, sixteen-bar renditions of classical works. After what felt like the twentieth toy featuring an ever so slightly off-key rendition of Brahms' lullaby, my husband and I had had enough. No more bad music! We refurbished an old TV stand into a cabinet that featured a wooden abacus, a shape sorter, a maze, and four magical wooden buttons. The buttons connected to a small computer that could stream whatever music we added to its four playlists. We dedicated one to children's songs, one to classical music, one to children's stories, and one to glorious, glorious pop music. With a push of a button, our toddler could play whatever pop music we'd added to the list. Does a child need to listen to Nirvana? *Entertain us.* KC and the Sunshine Band? *Shake, shake, shake.* Jurassic 5? *Let the beat unfold.* R.E.M.? *That's me in the spotlight.* The Beatles? *Hey, Jude.* Bowie? *Dance that magic dance.* Anything musically interesting went onto the playlist.

Including *Billie Jean, Beat It, Thriller,* and *Smooth Criminal.*

Having put those songs on there now feels like a moral mistake. Maybe?

I won't bother reprogramming the music cabinet. It stands mostly idle now; the kids are too big for music toys and

they've also figured out how to work my phone. But I wonder if I should. When I was a kid, trying to figure out how to moonwalk on the blacktop in the playground, Jackson was a star. In the intervening years, however, Michael Jackson's legacy has become decidedly more complicated.

Allegations that Jackson had molested young boys who were guests at his Neverland Ranch stalked him for years. In the early '90s, Jackson was accused of sexually abusing a child of a friend of the family, and the case was settled out of court. In 2003, Jackson was tried in a criminal court for the sexual abuse of more children, and he was acquitted in 2005.

Through all this he kept performing, releasing albums, and making money. Hardcore fans believed him to be innocent, an eccentric, emotionally stunted man whose early stardom kept him from having a childhood and led him to form close bonds more easily with children than with other adults. The ambivalence of nearly everyone else was captured perfectly by cartoonist Mike Luckovich on the occasion of Jackson's death in 2009. The cartoon depicts a haloed angel on a cloud, peering down from outside the gates of heaven at a horned devil, who holds a newspaper with the headline MICHAEL JACKSON R.I.P. The devil asks, "Shall we flip a coin?" At the time, the cartoon caused a minor scandal; surely it was too soon following his death to start debating his legacy.[1]

Following the release of the *Leaving Neverland* documentary in 2019, there is no coin left to flip. The documentary, released on the heels of the #metoo movement, painstakingly and luridly details Jackson's crimes. The portrait that emerges is that of a morally sick pop superstar, who used his fame and money and the promise of stardom to charm young boys so that he could sexually abuse them. The documentary's tale is sickening, and it's done its work. Michael's accusers are believed.

The timing of the release of *Leaving Neverland* surely helped its popular and critical reception, as it came at a time when the problem of sexual assault and harassment in the world of entertainment grabbed the spotlight. In October of 2017, Harvey Weinstein's production company fired him after scores of credible accusations of sexual harassment and sexual assault dating back decades. Shortly thereafter, the actor Alyssa Milano via the social media platform Twitter encouraged anyone who had been assaulted to write "me, too." The phrase itself had been used since 2006 by activist Tarana Burke on MySpace to support survivors of sexual assault; it comes from Burke's story of hearing from a young girl of an assault and wishing later that she'd had the presence of mind to lend her support by saying, "me, too."[2] Milano's post went viral, and many women shared their stories, using the hashtag #metoo, which lent its name to the movement. In January of 2018, Hollywood actors launched the #TimesUp campaign, which raised millions of dollars for a legal fund to help victims of sexual harassment in the workplace. At the 2018 Golden Globes, stars wore pins signifying their support of #TimesUp and #metoo. In the following year, it seemed that whenever one read about entertainment, there was someone new in the news who had been accused of some degree of sexual misconduct.[3]

Some artists finally faced tangible consequences for their behavior. The problem of sexual assault and harassment was no longer a mere problem of public relations, to be managed until public attention withered. After a teenaged boy accused Kevin Spacey of sexual assault, he was fired from the hit Netflix series *House of Cards*. After women comedians accused Louis C.K. of masturbating in front of them, distributors rejected his movie *I Love You, Daddy*. Bill Cosby was indicted

and later convicted on charges of rape from *decades* past. R. Kelly was indicted on charges of kidnapping, child sex trafficking, and statutory rape, allegations which had dogged him for years but only resulted in charges post-#metoo.

For fans of popular art, it seemed as if the stream of badly behaved artists would never end. As the movement grew, it expanded from those accused of serious crimes of assault to include sexual harassment and other forms of sexual misconduct. Fans of artists are stuck trying to figure out an answer to a thorny question:

Are we ethically required to give up the artwork of immoral artists?

As you might have guessed from the title (um, spoiler alert), I'll argue that most of the time, it's OK to continue to enjoy the artwork of immoral artists. I believe that the problems of sexual assault and harassment are serious, and those who commit such actions have wronged others greatly. The trouble is that fans, as consumers, are extremely poorly placed to punish artists or correct the culture that led them to think their behavior was acceptable. As a result, while it's certainly acceptable to decide to give up the work of immoral artists, most of the time, it's not ethically required for us to do so.

There are two popular arguments, however, that we need to address first, because if either of them succeeds, this book will be very, very short and my editor will be very, very mad. If you're like me, you probably heard or read versions of these arguments in popular media or in conversations with your friends when the scandals first broke.[4] The first argument says that it's OK to continue to enjoy the artwork of immoral artists, because we can always cleanly separate the art from the

artist. Condemn the artist, enjoy the art – the best of both worlds! The second argument says that it's not OK to continue to enjoy the artwork of immoral artists because we can easily substitute another artwork made by an artist who didn't harm anyone without losing anything. Find something else to enjoy – no loss!

Neither of these quick, dismissive arguments succeeds. The problem with the first argument is that sometimes the artist's life is intertwined with the artwork, and so we can't appreciate the artwork independently of the artist. The problem with the second argument is that artworks are unique and figure into our aesthetic lives in unique ways. Nevertheless, both arguments are worth examining more closely, because the ways that they go wrong reveal how we think about art, artworks, and ethical responsibility.

II.

Why *should* we care at all that the artist is a bad person? Start with the idea that enjoying artwork is a kind of consumption. In some cases, consumption is literal, as when we purchase tickets to concerts or art shows or buy books or streaming music subscriptions. We can also think of consumption metaphorically, as consisting of the choice to engage with art. On this understanding, I consume art, regardless of whether I've paid for it, whenever I engage with it. I consume novels that I read using my library card; I consume music when I listen for free on Spotify; I consume paintings and sculptures when I visit museums; I consume television if I borrow (ahem) a friend's HBO password.

At first glance, caring about the origins of the art that we love seems rather like being ethically concerned about any other consumption choice that we make. Many of us are used

to thinking of our consumption choices ethically. We might choose to purchase only sustainably caught fish, or drink only fair-trade coffee. We might debate the environmental impact of almonds compared to the environmental cost of meat. We might choose to bike to work rather than drive because we care about air quality.

If I decide that I should consume only ethically traded coffee, I'll focus on only some of the ethical issues that pertain to the coffee itself: how it was grown, how the farmers were paid, how much the farmers were paid, the conditions in which they labor, and so forth. The moral character of the barista who pulls my espresso is irrelevant to whether I think drinking it is ethically acceptable.

Similarly, we care about the ethical content of the artwork itself. We debate whether *Lolita* endorses or merely describes the grooming behavior of a pedophile. We worry about whether certain movies are appropriate for children, or whether a song glorifies violence. In the cases at the center of the #metoo movement, however, the content of the art is set to one side. The ethical problem with the artwork isn't driven by what it portrays or what it endorses. Rather, the problem with the artwork arises from the fact that an immoral person made the art.

The quick argument in favor of separating the art from the artist says: let's just treat art like we do any other consumption choice. If we're concerned about the ethical dimensions of coffee consumption we're not talking about the barista's moral character. We don't see suggestions that we stop purchasing Ford cars because Henry Ford was notoriously anti-Semitic or forbid driving on the Autobahn because Hitler supported its construction. The artwork is the product, and most of the time, we do not reject the product if it turns out that its creator was immoral.

So, we should draw a sharp line between the artist's life and the artist's work. We can condemn the artist for their wrongdoing but hold that the artist's character and actions should not factor into our evaluation of the artwork. Separating the art from the artist would be no different than separating the ordinary inventor of useful things from their creations.

Moreover, sometimes it seems easy psychologically for us to separate the art from the artist, especially when their life and work resides in the distant past. Many historically great artists were horrible people, and in a lot of those cases, we view their misdeeds as nothing more than a historical footnote, weird intellectual trivia to bring out at parties. The painter Caravaggio murdered a pimp by attempting to castrate him after a fight over a woman, but there haven't been calls to remove his work from museums. Charles Dickens callously attempted to have his first wife locked up in an insane asylum when she fell into crippling depression following the birth of their children, but this year many of us will watch one of the many versions of *A Christmas Carol*. Wagner was a deep anti-Semite, and his music forever associated with the Nazi regime, yet outside of Israel, fans of opera will flock to performances of *The Ring Cycle*.

There are several plausible explanations for the ease with which we separate the art from the artist in the case of long-dead artists. First, it's hard to the see the point of refusing to engage with their artwork. We'd lose the experience of their artwork, but without either consoling the victim or condemning the artist. Refusing to engage with their work seems like a mere exercise in self-abnegation, or petty moral grandstanding. (Oh, I always shut my eyes when I walk past the Caravaggio, don't you?)

Second, we might find it difficult to decide whether we should judge an artist's actions in the past by the morals of their contemporaries, or by modern standards. Many artists held political and ethical views that would be anathema today but were considered acceptable by their contemporaries. Standards of behavior have changed. Even when we endorse our current standards over the standards of the past, we might find ourselves moved by sympathy for those who did wrong. It was absolutely wrong for Charles Dickens to impugn his wife's character in an attempt to secure a divorce, but his desire to do so seems far more understandable in an age which forbids divorce except in cases of insanity than in an age where no-fault divorce exists, or when society recognizes that post-partum depression can be treated with medication, therapy, and support. Justified or not, historical misdeeds are mostly graded on a curve.

Finally, the truth of what happened in the past is often lost to time. Charles Dodgson, better known as Lewis Carroll, nurtured a friendship with the young Alice Liddell before immortalizing her as the titular character of *Alice in Wonderland*. Dodgson also made 3,000 photographs of young children, partially clothed or nude, including several of Alice herself. Victorian sensibilities thought of childhood as a time of untouched innocence. There could be nothing wrong with the nude form of a child, in their eyes, because nudity in young children was wholly innocent. Historians have professed skepticism at the innocence of his behavior, but with the passage of time and the destruction of Dodgson's diaries by his estate, it is impossible to determine what happened with any confidence.[5] As a result, we don't know what really happened between Alice and Charles, and so there doesn't seem to be an overwhelming reason for us to give

up the utterly charming and cracked adventures of the fictional Alice.

None of these explanations apply to the artists at the center of the #metoo movement. The immoral artists are still alive, so it seems plausible to think that they could be properly the object of public shame and punishment. Our shared culture means that we are more confident that they should have known how to behave ethically. Contemporary artists don't have the luxury of their secrets being lost to time, nor the benefit of the doubt that results from a spotty historical record. We have access to indictments and court records. Documentaries and tell-all books chronicle their misdeeds, and they and their PR firms get a chance to respond. As a result, we often feel much more confident that we know what happened, and that maybe we can do something about it.

Moreover, it's often hard to see a clear distinction between the artist's life and their work. Many artists draw on their own lives for inspiration, so that their work seems to be autobiographical, or serve as a justification for their behavior. There's also often a clear causal connection between the financial success of the artist through the sale of their artwork and their access to potential victims. Harvey Weinstein wielded an enormous amount of power, which allowed him to threaten and silence his victims, and he derived much of that power from the runaway financial success of his films. Justice might have caught up to a less successful producer years ago. The success of the artist and the artwork are linked; we cannot simply write off our choices as ethically neutral without at least looking into the question of how our choices can affect their behavior.

We also easily transfer the affections we have for the artwork to the artists themselves. When we find an artwork to be

particularly aesthetically inspiring, we're likely to feel close to the artist. It's hard not to have warm feelings toward an artist when their artwork is meaningful to us, or tied to a nostalgic memory, or reminds us of a loved one or a happier time. When something is that powerful and that beloved, it's easy to overlook how it was produced. The feeling of a connection with the artist can lead us to excuse wrongdoing or downplay its severity. The love of their art can become a powerful set of blinders to injustice, working against our moral instincts and leading us to rationalize our continued engagement with their work.

We cannot treat art just like any other consumer purchase. We can't automatically separate the art from the artist. Instead, we need to think through the ethical implications of engaging with the artwork of immoral artists, even if we wind up concluding that it's OK to do so. Blithely continuing to engage with their works means irresponsibly ignoring the possibility of contributing to harm.

III.

Let's turn to the second argument. Should we automatically give up the artwork of immoral artists? I'll start by making what I think is the most compelling case for thinking that the best course of action is to give up their artwork.

Any given work of art isn't something that we need to survive. We arguably need art to have a full life, and every human culture seems to have created art shortly after having food and shelter sorted out. Aristotle declared human beings the political animal, but he would have been as justified had he called us the *aesthetic animal*, the animal that beautifies the world just because it looks better that way. We'd survive without art, but to quote the post-apocalyptic novel *Station Eleven*, in turn quoting *Star Trek:Voyager*: survival is insufficient.

Still, you might worry that even if we are aesthetic animals, art is a luxury, and so is popular entertainment. Moreover, the bar for deciding not to bother with someone's art is pretty low. "I don't like it" is a good enough reason not to engage with someone's art; as the saying goes, there's no accounting for taste. If you don't want to watch Woody Allen films because you find his brand of boomer neuroticism uninteresting, then, while some might argue that you're missing out, the fact that you don't want to is usually reason enough not to bother. Surely, then, "I don't want to watch Woody Allen's movies because I believe he molested his daughter and I don't want to support that in any way" is a much more principled reason! If there's any chance that continuing to support the work of immoral artists indirectly supports the harm that they've done, we should give it up.

We can make this argument stronger. Giving up the works of these artists would not condemn us to beige, artless lives. Start with technology that's been around awhile, and free to access. Basic FM radio in cars provides many different stations, and many different styles of music; flip to AM, and hear people chatter about any variety of subjects. A TV with just a rabbit-ears antenna gets several different stations that show dramas, sitcoms, and sporting events. With nothing else, one would be able to fill up all of one's days with entertainment. Not all of it would be great. One wouldn't be bored, however, and one would have plenty of popular art to enjoy even subtracting all of the worrisome artists.

But leave the rabbit ears in the past; it's 2020. We can watch and listen to nearly whatever we want on demand. There's enough content to fill lifetimes. If we get bored with music, television, and movies, we may entertain ourselves by downloading and reading books and magazines. We can entertain

ourselves even just by scrolling through the list of movies that we could be watching were we not scrolling through an endless list of movies in search of something to watch. Non-narrative content on the Internet also competes for our entertainment attention. We can watch playthroughs of video games, skateboarders compete to see who can skate on the most ridiculous bodged-up contraption, videos of children opening boxes containing toys, and videos of adults opening boxes containing board games.

The entertainment industry promises that we will never have an idle moment that we can't fill with something, and they've delivered on that promise. We're not going to suffer if we decide to give up the artwork of a handful of bad offenders targeted by the #metoo movement. There are so many entertainment options and the cost to us as a consumer to find other artwork to enjoy is very low, so artists have to compete for our attention. Philosopher Shen-yi Liao points out that most of us choose what we listen to, for example, based on our friends' recommendations, or what's trending on social media, or on what the software algorithm thinks is likely to keep us listening longer. Whether the artwork is genuinely worthy of our time and attention doesn't really factor into what we happen to encounter and enjoy. If the competition for our attention has little or nothing to do with the quality of the artwork, Liao concludes, we might as well consider the morality of the artist as a relevant criterion.[6]

In summary, given that as ethically conscientious fans, we do care about their wrongdoing, we might feel like we shouldn't enjoy their artwork, and given the amount of entertainment that's out there, it will be relatively easy to find another artist that hasn't done anything wrong. We might like their work even more. In short, we won't lose anything by giving up any

of the artists in the #metoo movement that we can't easily get back by finding other artwork to enjoy. The ethically prudent option: give up their work.

The previous argument depends on two key assumptions. First, it presumes that artworks are fungible: that we can substitute one artwork for another with no loss to ourselves at all. Second, it presumes that the primary reason that we bother with artwork at all is to have pleasant experiences. Both of these assumptions, however, are incorrect. To show you why, we'll have to start by characterizing why we are drawn to art. While philosophers have been writing about beauty since Plato, the word *aesthetics* was coined in the 18th century by Alexander Baumgarten. Baumgarten wanted to figure out how aesthetics – embodied for him in the art of poetry – could contribute to knowledge. He argued that unlike logic, which abstracts principles and generalizes from examples, aesthetics focuses on particular objects and situations, delighting in complexity, individuality, and diversity. An educated mind needs not only the cold lines of logic and mathematics and the principles of science but the lively, vivid, and varied experience of beauty. Aesthetics thus provides a different, equally valuable, way of understanding the world.

In the intervening centuries, the term *aesthetic* has come to mean something more like "having to do with the pleasant response we have to beauty." Philosopher Frank Sibley enumerates a partial list of aesthetic expressions that will help us give a sense of the kind of thing we mean by "aesthetic": "unified, balanced, integrated, lifeless, serene, somber, dynamic, powerful, vivid, delicate, moving, trite, sentimental, tragic."[7] For our purposes, let's think of an *aesthetic experience* broadly as one where an object commands our close attention. Philosopher Alexander Nehamas describes the raw viscerality

of the aesthetic experience in this way, asking the reader to imagine the moment one spies a new beautiful acquaintance:

> And then, all of sudden, everything becomes background – everything but a pair of eyes, a face, a body, pushing the rest out of your field of vision and giving you a moment of awe and a shock of delight, perhaps even passionate longing. For a moment, at least, you are looking at beauty.[8]

For there to be an aesthetic experience, both the object itself must be interesting in some way, and we must be paying attention in the right way. We might both see the same pink-streaked evening sky, but if I think only "it's almost dark; we'd better start heading down the trail," and you think "how beautiful!" you're experiencing the sunset aesthetically, and I am not.

We can experience anything that we can perceive aesthetically. The *elegance* of the ballet dancer's arabesque? Aesthetic. The *balanced* acidity of your morning cup of coffee, and the *dynamic* mural painted on the wall outside your favorite hipster coffee shop? Aesthetic. The *delicate* lacy patterns of the frost on your car windows? The *powerful* growling bass of your favorite Scandinavian black metal band? The *serene* shimmer of the calm lake? You get the idea. Aesthetic experiences can be long, complex, and demanding or fleeting and electrifying. They can be trivial, or of ultimate importance.

Artworks, of course, are often the source of aesthetic experiences. Because the aesthetic experience involves our close attention on that particular object, and artworks are unique, those experiences aren't what economists call *fungible*. Money is fungible; if I borrow a dollar bill from you, you're satisfied

when I give you back a dollar, even if it isn't the same physical dollar as the one I borrowed, or if I Venmo you what I owe instead of giving you the cash. One dollar is as good as another.

The same isn't true of works of art. The aesthetic experiences that we have when we appreciate a certain work of art are specific to that work of art. You can't experience the texture of Chinatown by watching any old noir film. The infectious sunniness of ABC can't be replaced with Hey Ya! The experience of seeing the Buddhas of Bamyan just can't be replaced by the experience of seeing the Mona Lisa. If we lost of all Beethoven's works in a fit of mass destruction and collective amnesia, we couldn't replace them by performing more Brahms.

You might be worried that most of the works at the center of #metoo movement aren't Art-with-a-capital-A. If we heard that someone was a patron of the arts, we'd probably expect him to be attending the ballet, or the opera, or the symphony. Perhaps he spends his time snootily going to art museums. If Jackson's music, Polanski's films, and Cosby's comedy can't be art, then we might be suspicious that engaging with them gives us unique aesthetic experiences. If we don't have aesthetic experiences, then it's much easier to make the case that we can replace the pleasure we get from engaging with their work.

Philosophers have spent a long time arguing about the characteristics of art. It turns out that it's devilishly hard to define art because, for nearly every criterion one might give, it's trivially easy to find a counterexample. If we say that art is supposed to represent the world beautifully, then it's hard to know what to say about non-representational arts like music. If we say that art is whatever people who run museums are willing to accept, then it seems like street art and folk art can't

be art. If we say that art has to be complex, then we won't know how to interpret minimalist art.

We might also reasonably worry that the task of defining art is shot through with assumptions about wealth, class, and race. And, unsurprisingly, it often turns out that whatever wealthy people who write tomes on aesthetics like turns out to be art, and whatever those peasants over there are doing counts as merely skilled crafts. To call something "art" is to praise it, so it is practically impossible to ask whether something is art without implying a value judgment about whether it's also worth our time or money.

Some philosophers would argue that we need not worry about the question of whether something is art at all, rejecting the distinction between "mere entertainment" and "art" as not terribly meaningful. I'm sympathetic. Still, as we're looking at this question through the frame of artwork and aesthetic response, it will be good if we have at hand at least a rule of thumb that will allow us to allow that pop music, rock, comedy, and film can be art. Philosopher Berys Gaut devised a set of criteria that captures a lot of the qualities that we think something must have to be an artwork.[9] Artworks typically have positive aesthetic properties, convey meaning, express emotion, and challenge the intellect. Art usually exhibits a complex and coherent structure, bears the individualist marks of the artist who created it, and results from a high degree of skill. Artworks usually are identifiable as participating in part of an established form of art.

When we try to figure out if something is art, we see how many of the criteria it satisfies. There isn't a hard and fast rule of how many categories have to be satisfied. For Gaut, and for most of us, we'll know whether something is art when we see it.

If we assume Gaut's criteria are correct, many of the popular entertainers we've been discussing are producing art. Maybe not all of them produce art, and maybe of those that are producing art, maybe not all of the time. (Sturgeon's Law cheekily proclaims that ninety percent of everything is crap; there is no artistic defense of the viral hit "Baby Shark," whatever my four-year-old thinks.) Many of their works, however, are artworks, and when we engage with them properly, we have unique aesthetic experiences.

Because each aesthetic experience is unique, we cannot simply substitute one artwork for another. We might have thought that we are morally required to give up the artwork of immoral artists because it was a no-cost way to signify our opposition to their crimes, but there is an *irreplaceable cost* to giving up an artist. Great artworks aren't interchangeable, and the aesthetic experience of enjoying great art is part of a well-lived life.

This means that the supposedly ethically prudent option is less appealing. Asking someone to give up a beloved artwork isn't cost-free.

If we expand our understanding of our aesthetic life, however, we can make an even stronger argument for the claim that giving up an artwork isn't trivial. Making this argument is going to require a little bit of philosophical architecture, but the basic idea is easy to grasp. Philosopher Dominic Lopes has argued that the historical understanding of aesthetics as concerned with obtaining pleasure is woefully limiting.[10] We don't merely passively experience art by appreciating it. We are aesthetic agents: we act aesthetically. Lopes writes that "aesthetic agents are not born; they follow lifelong trajectories, not calling it a day once they have mastered finger painting or Harry Potter; and they welcome new things."[11]

We care about aesthetics not only to appreciate beauty but to *catalog, criticize, create, theorize, achieve, teach, share,* and *develop expertise in* what we love. We develop aesthetic values. We take aesthetic reasons as motivations for aesthetic actions.

We can grasp what he means through examples. A college student dyes her hair a brilliant green and artfully chooses her clothing and shoes. A father of two enrolls his children in piano lessons so that they can learn classical music while young. A zealous fan of movies watches and ranks every M. Night Shymalan film. A couple waits to watch *Ozark* together instead of each of them bingeing it solo. A teenage artist draws manga of the cast of *Hamilton*, which she's never seen, based on the soundtrack she streamed. A grandmother records herself reading Dr. Seuss for her grandchildren's bedtime stories. A group of friends gathers weekly to play their newest board-game acquisition.[12] A novice baker achieves large spongy holes in the sourdough bread she baked during the quarantine of 2020 and posts a picture to Instagram. A writer 'ships her favorite *Firefly* characters.

To make sense of these activities, we need to understand the relationship between aesthetic value, aesthetic reasons, and aesthetic acts. They're interlinked. Something is an aesthetic value if it generates some aesthetic reason to undertake some aesthetic action. The beauty of the sunset generates an aesthetic reason for us hikers to stop and *admire* it. The joviality of Dr. Seuss rhymes generates an aesthetic reason for the grandmother to *record* herself reading it aloud. The aesthetic achievement of a perfectly elastic sourdough generates an aesthetic reason to *post a picture* to Instagram.

You might be wondering at this point how an aesthetic value gives us an aesthetic reason to act at all. Why should we care about aesthetic value? Lopes casts aesthetic value in

terms of achievement within the context of an established social practice.[13] Lopes's example of *beausage* captures the kind of achievement that's meant. "Beausage" is a portmanteau of the words "beauty" and "usage," and it refers to the beauty a bicycle develops through the scratches, wearing, and chips in its paint that show that it's been ridden. The community of bicycle afficionados has recognized beausage as encapsulating their attraction to expensive handmade bicycles: beautifully crafted works of art, yet functional machines meant to be enjoyed on the road. What might be termed "light cosmetic damage, consistent with use" in an advertisement for a secondhand bicycle becomes, though the community, a badge of pride in miles ridden, to be enjoyed aesthetically. One custom bike builder will even give a new bike its ceremonial first scratch, for a fee.[14] The scratch is made aesthetic by the practices of the cycling community.

Other philosophers have developed or gestured at different answers about the importance of aesthetic values, reasons, and actions. Our aesthetic actions express our aesthetic personality.[15] They define our aesthetic style.[16] They challenge our aesthetic attention, forcing us to flex mental muscles that we're likely to neglect otherwise.[17] They express our aesthetic love for the artwork.[18] Our aesthetic actions also create community and opportunities for meaningful connections with other people. Caring about beauty makes our world a little more *awesome*.[19]

Sometimes our aesthetic reasons derive from what I'll call an aesthetic project. Any project is a planned undertaking with an identifiable goal and a set of practices or actions that aim to bring that goal about. The project *remodeling the kitchen* aims at creating a new, modern, and functional kitchen. To bring it about, the DIY remodeler must *set a budget, choose a design, purchase*

the materials, *demolish the old kitchen*, and *install the new flooring, tile, cabinets, countertops*, and *appliances*. The project provides practical reasons to undertake the practices. Demolishing your kitchen *so the new floor can be installed* is valuable as part of the project of remodeling the kitchen. Demolishing your kitchen *for no reason* would be a senseless act of destruction.

Aesthetic projects have the same structure as other kinds of projects. They have an aesthetic goal and prescribe practices that lead to that goal. The decision we make to pursue an aesthetic project provides aesthetic reasons for us to undertake aesthetic actions. The father whose aesthetic project is to *pass on his love of classical music to his children* has reason to enroll them in piano lessons, ensure that they practice, play classical music for them, and buy them biographies of famous composers. The teenaged manga artist who is a fan of *Hamilton* has reason to follow reddit threads about the musical, to try out new drawing techniques, and to read the Chernow biography that inspired composer Lin-Manuel Miranda.

What reasons do we have to think that aesthetic projects themselves are valuable? We can start by looking around, as a sort of natural experiment. If aesthetic projects weren't valuable to most people, we'd expect them to be relatively rare. We'd expect a world where most people ignore aesthetics entirely, with no thought given to beauty in any aspect of our lives, but that's not what we see. People pursue aesthetic projects avidly.

We can also see the value of aesthetic projects by contemplating the value of aesthetic autonomy. Nehamas asks us to imagine a world where everyone defers to aesthetic experts, the ideal critics who tell us what is aesthetically worthwhile. These critics have great taste. They understand beauty and have impeccable style. Clothes are stylish, décor beautiful, dinners

delectable, and music enchanting. It's a magical place. It's one where we adopt whatever projects the experts say is aesthetically worthwhile.

Nehamas calls this world "nightmarish,"[20] and explains that our aesthetic values are "marks of distinction."[21] They express our individuality. Applying someone else's preferences and rules is *bad* taste. Our aesthetic autonomy is important; it matters not just what we choose aesthetically to pursue, but *that we chose it*. Philosopher C. Thi Nguyen offers another reason why we shouldn't want to mold our preferences to whatever aesthetic experts say. We value the activity of aesthetic engagement more than we value having the right aesthetic conclusions.[22] There's something off about submitting our aesthetic preferences to someone else's judgment. The point isn't to *have* the right aesthetic preference. The point is to explore what you find beautiful and striking and elegant and stunning without a thought as to the expert's opinions.

We can recognize the value of other people's aesthetic projects even when they don't appeal to us. We might admire someone's passion for movies while preferring to lose ourselves in avant-garde science fiction. We might like someone's sense of street style on *them* but prefer plainer conservative clothing for ourselves. We might admire a friend's commitment to performing bluegrass but choose to spend our time designing knitting amigurumi.

Here's my quick take on one significant source of aesthetic value. An imagined world of aesthetic uniformity is undesirable because it would override our aesthetic autonomy. We exercise our aesthetic autonomy when we choose what aesthetic projects to pursue. The default option with respect to aesthetic projects is that, within reason, *you get to decide which aesthetic projects to pursue*. Our aesthetic projects derive some of their

value from the value of our aesthetic autonomy, and our aesthetic values and reasons derive from the framework that the aesthetic project provides. The aesthetic value that I ascribe to playing Michael Jackson's music for my children derives from my decision that *introducing my children to a wide variety of musical influences* was a worthwhile aesthetic project to undertake.

Here's why this matters. The power that aesthetic projects have to bring meaning to our lives and the autonomy we have over the choice of which projects to pursue mean that asking us to give up a beloved artist in response to their wrongdoing might not be a *small* request. A beloved artwork might be valuable not just for the pleasure that we feel when we engage with it, but because of its place in an autonomously chosen aesthetic project. Asking us to give it up "just to be safe" is to ask us to substitute someone else's aesthetic judgment in place of our own and to surrender our own aesthetic autonomy to another.

Of course, sometimes our aesthetic projects conflict with our other priorities. We care about more than aesthetics. We have other projects. A fashionista's love for expensive pret-a-porter clothing might be outweighed by the need for practical, machine-washable garments upon the birth of her first child. A dedicated film buff might spend less time working through the Criterion Channel catalog if his new love interest prefers playing boardgames. Lopes quips that sometimes the desire to lie on the sofa and listen to Amy Winehouse loses out to the pressing need to do one's taxes.[23]

I'm not ruling out that one's aesthetic project might conflict with one's ethical values, or that one might turn out to be required to give up an artist because of their immoral actions. Or that we might just be so sickened upon learning what an artist has done that we lose enthusiasm for our aesthetic projects. But there's a difference between deciding, after

deliberating, that I will revise my aesthetic project because of my ethical commitments, and preemptively jettisoning my aesthetic project based on a news report of an artist's bad deeds. Our aesthetic lives matter too deeply to us to give them up thoughtlessly.

IV.

Neither of these quick arguments is decisive. Giving up the work of immoral artists means at least the loss of unique aesthetic experiences and might mean radically revising our aesthetic projects. Completely ignoring the misdeeds of immoral artists is ethically irresponsible. There aren't easy answers.

I'll argue that we do not have to give up the artwork of immoral artists. The argument I'll develop builds on the insights in the previous sections. Our aesthetic projects matter deeply to us, and we are free to choose which aesthetic projects to pursue. Because of the presumption of autonomy over our aesthetic projects, any demand to give up that autonomy because of ethical considerations must clear a high bar. We have to weigh the effects of a supposedly ethical action – giving up the artwork – against the potential loss of a meaningful aesthetic project. I'll argue that the expected societal benefits of giving up an artwork are small. Consumer activism just isn't as powerful as we might hope. As a result, the average fan can ethically continue to enjoy their favorite artworks, even while they rightfully condemn the artist.

The next two chapters form the bulk of my argument for this claim. In Chapters 2 and 3, I'll consider boycotts. A boycott aims to bring about some improvement by denying the target of the boycott money and attention. Boycotts have clearly defined goals, and in Chapter 2, we'll focus on goals that relate to the artists. Perhaps we aim to punish the artists

for their wrongdoing because the state didn't manage to do it on our behalf. Perhaps we want to avoid being complicit in their crimes. Perhaps we want to send a message to other artists that harming others means incurring financial penalties. We can ask, in each of these cases, whether we're ethically required to join these kinds of boycotts by giving up artworks. To figure that out, we have to look at whether those boycotts are likely to work, and whether our contribution matters.

I'll argue that most of the time, it just doesn't matter what we do, for a variety of reasons. Boycotts rarely succeed. Some artists are so successful that they're boycott-proof. Some artists achieved success long before their allegations came to light, so boycotting them now does nothing. As a result, we wind up weighing our aesthetic projects against largely symbolic, pointless actions. It's plausible to think that we would have to give up an artist's work if doing so would end sexual harassment and assault or at least put a dent in the problem. It's far less plausible to think that we have to give it up in protest to have *no effect at all*.

In Chapter 3, I consider boycotts that focus on supporting survivors of sexual assault and harassment. Here, the aim isn't to punish the artist but to change the culture. Survivors of sexual assault and harassment face a culture that's sympathetic to their attackers, and systematically undermines their testimony. The result is that immoral artists could act with impunity. They could *get away with it*. Some of the highest-profile cases in the #metoo movement chronicle *decades* of abuse. One has to wonder how different some of these stories would have looked if the artists had been fired or prosecuted after their first crimes. If we want to create a culture in which not only are victims of sexual assault and harassment believed but sexual assault is also less likely to happen and to be tolerated when it does, we need to demonstrate through our behavior that we detest assault and

believe victims. We boycott immoral artists not to change their behavior but to change the environment in which we live for the better. This is the strongest argument that I can muster in favor of giving up the artwork of immoral artists, but I'll argue that it doesn't succeed. We absolutely have an ethical obligation to support survivors of sexual assault and harassment. We absolutely have an ethical obligation to change the culture. I'll argue, however, that we can successfully pursue that ethical project even if we simultaneously pursue an aesthetic project that includes the artwork of immoral artists.

The #metoo movement raises other ethical questions. In Chapter 4, we'll return to the question of separating the art from the artist. In some cases, we find it nearly impossible to separate the art from the artist. Trying to enjoy the artwork immediately brings to mind the artist's crimes and makes it impossible for us to enjoy the artwork. We might wonder, however, whether we're making a cognitive mistake, rather like the person who thinks that the actor who plays the doctor on television really knows about medicine. Are we making a mistake if we allow our judgment of the artist to influence our artistic judgment of the work? I'll argue that we're not. Sometimes we find ourselves unable to separate the art from the artist, and that means that we can't pursue our aesthetic projects with the same love as we did before.

The #metoo movement would be impossible without the existence of social media. (The hashtag should have been a clue.) Twitter, Instagram, and the like make it easy to join the madding crowd in decrying the behavior or opinions of an artist. If a hashtag or a tweet "goes viral," it can potentially have a large impact on the fame and fortunes of an artist. An artist who is presumed to have violated social norms ranging from opinions or jokes in poor taste to sexual misconduct risks

being "canceled" or systematically shunned, to deny them attention, influence, and money. Most of the time, as I argue in Chapter 2, boycotts don't work. Yet I think there are good reasons to be cautious of calls to cancel artists. Social media does not encourage careful deliberation or taking time to think before posting or reacting, and so it is capricious. More worryingly, social media rewards moral grandstanding, publicly posturing that one is on the right side of the issues by posting or reacting in the right way, and I'll argue that participating in canceling risks undermining genuine ethical discussion and genuine ethical growth. I'll take up this question in Chapter 5.

In Chapter 6, we'll return to the question of aesthetic reasons and aesthetic value. I'll argue that aesthetic communities offer a richer range of ethical options than the traditional debate about immoral artists offers. Thinking of the problem of immoral artists as one that's addressable only by giving up the artist ignores how aesthetic communities create new opportunities for ethical life.

It's OK to enjoy the artwork of immoral artists. That conclusion might shock you. Many of us have strong feelings when we think about how we should react to the #metoo movement, the art of morally troubling artists, and the world of social media-fueled outrage. We might feel anger, disgust, revulsion, or betrayal. Reading lurid press accounts or watching television specials might call to mind personal instances of being the survivor of abuse. The accounts are genuinely upsetting. We might feel that we have to do something in response to the allegations.

Sometimes, however, our feelings mislead us. Left to our own feelings, we're more likely to put our own interests ahead of everyone else's. We're likely to be lazier than we should be. We're likely to be suspicious of outsiders or people who look

differently than we do.[24] We can all think of situations where our automatic, knee-jerk reactions turned out to be unreliable. There are also times when we're just not sure what the right thing to do is. Aristotle observed two millennia ago that there are no ethical prodigies like there are mathematical and musical prodigies. To be ethical requires life experience and the habit of living and thinking ethically. Philosophy helps us identify the reasons that underlie our gut responses, so we can see if they can stand up to rational scrutiny.

Let me be crystal clear. If you no longer can stand the work of an artist after learning about their immoral actions, you have absolutely no obligation to try to get over it. The question I'm taking up is whether we *have* to structure our aesthetic lives to exclude the work of immoral artists, not whether you can. That's not at all the point of this book. Aesthetic autonomy is a powerful thing. *You get to pursue the aesthetic life that you want.* You have just as much autonomy over your aesthetic projects as anyone else, and if it forms an important part of your aesthetic identity to *enjoy the works only of those artists whose lives I can endorse,* that's absolutely fine. You have the right to decide how your aesthetic life goes.

Even if you're inclined, however, to kick immoral artists and their artwork out of your life, thinking philosophically about the question of the art of immoral artists is valuable. We might find that thinking philosophically makes us more aware of how we construct our aesthetic lives. We might grow more comfortable in the decisions that we've made when we evaluate our reasons. We also might find that some of our initial intuitions were misguided and that we should reconsider our initial reactions. We might find that questions that on the surface seemed to be simple grow ever more complex as we delve deeply into them.

I won't be sitting in judgment on all the specific cases of immoral artists that we could consider. Part of my reluctance to do so is purely practical. There are too many artists, too many works of art, and too many new and changing revelations. Any attempt to have the final say would be surely overwritten before the book was even published.

Part of my reluctance, however, concerns methodology. The work of philosophy often tries to answer to important practical questions of how we ought to live, but it also models how we should search for answers. Given the autonomy that we have over our aesthetic projects, it's going to be next to impossible for me to judge whether giving up a work of art represents a small or great sacrifice for you. Are you using the art as mere entertainment, something to have on in the background while you scroll through Facebook? Are you enjoying it as an artwork casually? Does it form the backbone of an aesthetic project to which you've dedicated time and energy?

Philosophy, then, needs most to model *how* to search for answers. I am fond of a passage from the end of the Platonic dialogue Laches, which features Socrates and his friends in conversation about the nature of courage. They begin by defining courage in terms of military regulations, but as they examine the definition, they find that none of their proposals quite capture what they intuitively understand courage to be. Their conversation was productive, even though they did not successfully define courage, because it showed them what they had believed without reflection was inadequate, and it helped them to discover what they valued. By the end, Socrates and his friends, having found that none of them knew as much as they thought they did, decide that the best thing they can do is commit to further study. We should do the same.

Two

I.

Most of the time, we don't bother trying to justify our aesthetic and artistic choices on ethical grounds. If you enjoy rap and I prefer reggaeton, we disagree. We might try to persuade each other of the appeal of our favored artworks. We might dispute good-naturedly with each other about which is better. We're unlikely, however, to think that the other person is making an ethical mistake by following their aesthetic preferences. Most of the time, our aesthetic decisions are thought to be ethically neutral.

The #metoo movement and its related publicity put pressure on that supposed neutrality. Some of the art we enjoy was made by monstrous men.[1] We're now aware, even uncomfortably aware, that our choices of what art to engage could have ethical implications. What seems to be at first glance an innocent decision to pursue our aesthetic lives is ethically worrying.

What is an ethically conscientious fan to do? The popular discussion of the question assumes that the available alternatives are to continue to enjoy the artwork or to give up the artwork. While I'll challenge that assumption in Chapter 6, it captures something right about how we think about the revelations of the #metoo movement and our ethical obligations to respond to them. Fans need to weigh the aesthetic value

they reap from engaging with the artwork against the ethical value of giving up the artwork.

On one influential way of characterizing ethical decisions, utilitarianism, we are ethically obligated to choose the option that brings about the most good for the greatest number of people. Thinking through an ethical decision is rather like toting up the pros and cons of any other big decision: we look at the expected consequences and pick the best result. If there's a tie, then both options are equally ethical permissible and it doesn't matter, from the perspective of ethics, which one we pick.

We already have a rough idea of the aesthetic value of engaging with artwork. Enjoying art and pursuing aesthetic projects are part of a well-lived life. The proposed ethical reasons are somewhat harder to tease out. It's hard to nail down exactly why continuing to engage with the artwork of immoral artists would be ethically wrong. What's supposed to happen when we give up their artwork? Without an answer to that question, we won't be able to figure out whether we're ethically obligated to give up the artwork.

One appealing thought is that giving up such artists' work constitutes a kind of consumer boycott. If so, then we have to consider that we are ethically obligated to boycott the artist in order to bring about some positive social change. Philosopher Linda Radzik provides a handy framework for thinking about how boycotts work, writing that

> boycotting involves one party pointedly withdrawing from or avoiding interaction or cooperation with another party. Different types of boycotts can then be distinguished by

- *who* is withdrawing,
- *what* forms of interaction or cooperation they reject,
- from *whom* they are withdrawing,
- and *why* they are withdrawing.[2]

To determine whether a boycott is ethically responsible requires identifying each of these four conditions. For example, in the U.S., every schoolchild learns of the success of the Montgomery Bus Boycott organized by Rev. Dr. Martin Luther King Jr. The bus company, like many others at the time, segregated passengers according to race. Black customers were required to sit at the rear of the bus, and, should the bus become full, give up their seats to white customers. Those who violated the policy, as Rosa Parks famously did, could be charged, convicted, and fined; segregation always has the force of the law behind it. King's group vowed to refuse to ride the buses until the policy (and the law) changed. To put this in Radzik's terms, the Black protesters withdrew from the Montgomery Bus Company by refusing to ride the bus, in order to protest the injustice of racial segregation.

It is easy to identify these four conditions at work in the calls to boycott artists. *Who* is withdrawing? Fans of the artwork of immoral artists. What forms of interactions or cooperation do they reject? Engaging with their artwork, especially when it involves continuing to give them money. From *whom* are they withdrawing? Immoral artists. *Why* are they withdrawing? To protest the artist's wrongdoing. If we can answer these four questions, we can answer the preliminary question of whether the boycott is ethically appropriate. Although I'll offer some reasons to be cautious about joining boycotts of celebrities in Chapter 5, at first pass it seems that boycotting

an artist over serious wrongdoing is always ethically appropriate; you're not doing anything wrong if you decide to give up a beloved work of art over the abhorrent behavior of an artist.

But what we're looking for here is a reason to think that a boycott of immoral artists is *ethically required*. We need to know, expanding on Radzik's schema:

- what is the aim of withdrawing?

The aim of a boycott answers the question: what do we hope to accomplish by withdrawing?

For example, imagine that the owner of your favorite local café writes a racist letter to the editor that's published in the local paper. You and your friends want to organize a boycott in protest. It's important to you practically to know what you're hoping to accomplish so you can adjust your tactics appropriately, and so you know when your boycott has succeeded. Do you want him to publish a retraction? Make some kind of public amends? Go out of business entirely?

Determining whether it's ethically required to join a boycott also requires us to consider more than just the importance of the ethical wrong that the boycott is protesting. We need to consider whether the aim of the boycott is proportional to the offense. We need to consider whether the boycott is likely to succeed. We need to consider the effects of the boycott on innocents, like low-wage employees, on the broader community.[3] Any ethical analysis of a boycott has to include taking account of those unintended side effects, delicately balancing the aims of the boycott with the damage the boycott will do those not directly targeted by the boycott.[4]

As a result, in order to evaluate whether joining a boycott is ethically required, we must also ask: what's the point of the

boycott? If we're going to figure out whether we ought to give up the work of an immoral artist, we need to look at the potential *specific* aims of any proposed boycott. The national conversation about the #metoo movement reveals a variety of potential aims, and they're not always well-defined. We can group the potential aims, however, into two rough categories: those focused on the artist's behavior and its immediate effects, and those focused more generally on expressing solidarity with the idea that such behavior is intolerable.

I'll take up the expressive reasons in the next chapter. In this chapter, I'm going to focus just on the probable aim of boycotts that have something to do with the artists themselves. Here are three plausible aims of consumer boycotts that focus on our interaction with the artist. Our aim might be to punish the artist's wrongdoing extrajudicially, by denying them money, fame, or attention. We also might aim to show our support for the victims. We might also aim to avoid being complicit in the harm that the artist has done.

We'll need to evaluate each of these aims separately. Here's the sketch of how this will go. Suppose, for the sake of argument, that *punishing the artist* is an ethically praiseworthy goal. It would be *good* if boycotts aimed at punishing the artist succeeded. If giving up an artwork means that the boycott would succeed in punishing the artist, then we are ethically required to stop engaging with their artwork. I'll show, however, that it is reasonable to believe that most consumer boycotts will fail. Without the collective support of others, we're left weighing the considerable aesthetic value that engaging with the artwork represents to us against the infinitesimal (that is, teeny-weeny) effect boycotting the artist would have on their success.

Alternatively, the aim of the boycott might be to support the victims of the artist. If supporting the survivors is something

we're ethically required to do, and boycotts effectively support the survivors, then we are ethically required to boycott the artists. I'll show that boycotts are not an effective way of supporting survivors, even in those cases where the survivors welcome the attention.

Another aim of a boycott might be to avoid being complicit in the artist's immoral behavior. If engaging with their art means indirectly contributing to the harm of others, we'd have a powerful ethical reason to give up their art. I'll argue, however, that we're not complicit in what the artists have done if we continue to engage their artwork.

In all three cases, the ultimate reason that it's OK to continue to enjoy the artwork is that as consumers, our power is very limited. The artists and their work may be important to us, but we are not important to them. As consumers, we shouldn't expect that anything we do will meaningfully affect most artists. As a result, whether we boycott their work doesn't matter ethically.

II.

Let's consider the first artist-centered proposal. Fans (the "who") of immoral artists (the "whom") stop engaging with their artwork (the "what") in order to protest their wrongdoing (the "why") and punish the artist (the "aim"). In order to determine whether we're plausibly required to give up the artist's work, we have to evaluate the ethical value of the aim, and whether the actions open to us could plausibly bring it about. Is it good to try to punish an artist financially? Is it plausible that giving up their artwork would accomplish that?

For now, let's suppose that it's always ethically acceptable to join boycotts of artists. What's the case for thinking that we ought to join a boycott in order to punish them? Many of the

artists accused of sexual assault escaped legal punishment. The #metoo movement saw a few arrests, but for many artists, such as Kevin Spacey, most of the consequences were financial: canceled contracts, lost appearances, and drops in sales of their work. The market serves here as a replacement for legal justice: act badly, and no one will buy your stuff.

When we consider whether giving up their artwork is an effective way to punish the artist, however, we immediately run into some practical objections. Let's get them out of the way first. Boycotting a dead artist doesn't punish them. Jackson died in 2009, having been found innocent in the courts in 2005; the *Leaving Neverland* documentary, which persuaded many people of the truth of his accusers' claims, aired in 2019. Boycotting Jackson *now* doesn't affect him. It affects only his legacy. People care about their legacies but taking away their legacies ten years after their death doesn't retroactively punish them during their lives.

Moreover, when we talk about giving up an artist's work in the context of a consumer boycott, we're implicitly assuming that doing so would be *noticeable* by others, if only in the form of a small contribution to declining sales. This is a seemingly small but significant point. When we think about boycotts as punishing the artists, we're not really considering the ethics of engaging the artwork, but the ethics of continuing to contribute to them financially. This presents a practical problem: how can we possibly boycott someone if we're not buying their artwork? (Let's set aside the obvious joke: it's permissible to enjoy the work of immoral artists only if you can pirate their work.)

Many of the artists we love produced tangible work that we own. For example, Bill Cosby's comedy albums have been a part of my life as long as I can remember. My parents purchased

them on vinyl when I was a small child. The purchase happened over thirty years ago. I wouldn't know *how* to boycott his Noah's Ark sketch in a way that would be distinguishable from me just no longer listening to that album. (Search for it on YouTube and resolutely refuse to click?) If, like one of my friends, you have a Thanksgiving tradition of watching *Hannah and Her Sisters* from a VHS tape you bought twenty years ago, whether you continue that tradition or discontinue it isn't going to affect Woody Allen now at all.

Even those of us who haven't succumbed to streaming everything still purchase a lot of new art, of course, but there's still a sizable chunk of popular art for which any financial transaction happened decades ago, and as a result, a set of artists that are functionally boycott-proof. Some of them, like Jackson, could have been meaningfully affected by a boycott had it happened decades ago, but now, anything we can do is too little, too late.

Another concern that we might have about boycotting an artist is that there often isn't a single artist to boycott. Most of the artworks implicated by the #metoo movement are the product of artistic collaboration rather than the production of a single artist. Record-setting pop songs, blockbuster movies, long-running television serials require the work and talents of many people. Consider the case of Harvey Weinstein. Harvey Weinstein founded the entertainment company Miramax and later the Weinstein Company, after the successful sale of Miramax to Disney. The producer's primary function is to fund the movie, so we might see their primary artistic contribution as deciding which of the many promising artistic projects to bring to the screen. Weinstein has produced many critically acclaimed and aesthetically successful movies, including *The Crying Game*, *Shakespeare in*

Love, and *Gangs of New York* as well as musicals like *The Producers* and *Billy Elliot the Musical*.

In 2017, the *New York Times* and *New Yorker* reported that Weinstein had serially sexually harassed or assaulted many women. Ronan Farrow wrote that his behavior had been an "open secret" in entertainment circles, but Weinstein had avoided justice through legal threats and non-disclosure agreements. One executive alleges that Weinstein systematically preyed on women, using his assistants to arrange meetings with those whom he targeted, and then dismissing his assistants, leaving his eventual victim alone and vulnerable. The reports that first trickled and then flooded suggest he had a pattern: propose a professional meeting, change into a bathrobe, and assault or demand sexual favors. When victims refused or protested, stories would suddenly appear in the press impugning their character.[5] Their careers disappeared. Weinstein was arrested, charged with sexual assault, and his trial concluded in early 2020 with his conviction. His production company fired him and has since dissolved.

On the assumption that Weinstein still financially benefits from the projects that bear his name, a successful boycott could do a lot of damage to his finances. A significant amount of the total profit from a movie goes right to the producers. As Weinstein's made a lot of films, a boycott of all the movies from his production house would affect him significantly.

A boycott of his movies, however, would also wind up harming lots of people who worked on those movies. The actors, for example, who have done nothing wrong wind up headlining a box office flop, and because they're the headliners, a failure does more to damage their career than it does Weinstein's. Think of all the people behind the scenes who needed to work on a Weinstein film to get experience

as a foley or a best boy or a cinematographer or a costume designer. They'll suffer the knock-on effects of a boycott, too.

To make matters more complicated, some of the people involved in the making of Weinstein-produced movies were undoubtedly his victims. Boycotting the film would harm them further. First, they have to deal with his predation, and then they have to deal with well-intentioned fans refusing to see what they've made on the grounds that Weinstein might benefit. The trouble is that large, spectacular works of popular art involve the contributions of many people. Aiming to take down Weinstein harms many innocent people. Boycotts aren't scalpels that directly target wrongdoing. A boycott of Weinstein could conceivably fail to punish him while causing genuine harm to innocents through its ultimately ineffective disruptions. He'd still be rich. The people who worked with him would be tainted by association.

To be absolutely clear, nothing I've said here lends itself to saying that Weinstein shouldn't be *prosecuted* for his crimes. He's been convicted of sexual assault, sentenced to 23 years in prison, and some of those who made their careers with him suffer from the fallout. Nevertheless, no one should reasonably think that a man should be immune from criminal prosecution because he creates art with other people. A consumer boycott, however, probably won't punish Weinstein; it's just not a good tool for punishing producers.

The objections we've considered so far point to the difficulty of making generalizations when it comes to the #metoo movement. Much depends on whether the artist is alive, how close in time the allegations come to the financial peak of their career, and the nature of the artworks that they produce. Some artists, however, won't be seriously affected by a boycott. The practical effect on them will be nothing. When we

weigh the loss of significant aesthetic value against *nothing*, aesthetic value wins every time.

III.

Let's set the cases where artists are untouchable by boycotts to one side. To determine whether there are other reasons to reject an ethical obligation to boycott artists in order to punish them, we need to look more closely at the structure of boycotts. Boycotts result in "social dilemmas," informally known as "collective action problems." A social dilemma occurs "when the interests of the individual members of a group are at odds with the collective interests of that group."[6] This creates a motivational problem. An individual caught in a social dilemma has to choose between their own interests and the collective interests of the group. If they choose the collective interests of the group, but other people do not participate, then they will bear all of the cost while reaping none of the benefits.

For example, it's unquestionably good for the planet if we all reduce our consumption of animal products, especially beef. The science is clear that raising and eating animals contributes a lot to climate change. Yet even the most meat-loving person among us at most contributes only a very, very small amount to the great harm that meat production causes. If one person decides to give up meat to save the planet, they'll incur a lot of cost. They'll lose not just the pleasure of eating meat but also many of the cultural and social goods that meat-eating has fostered; think of the challenge that the typical American Thanksgiving celebration presents for a vegetarian or vegan.

One challenge of some collective action problems is how to think about them ethically. Suppose that society collectively has an ethical obligation to reduce the amount of meat

that it consumes. What does that mean for us as individuals? Our individual eating choices won't affect much unless we are joined by many other people; are we ethically obligated to reduce our own consumption? Philosopher Derek Parfit argued that we *do* have an ethical obligation to contribute to collective goods and avoid participating in collective harms, even when our own contribution alone doesn't do anything unless others also contribute. He writes,

> It is not enough to ask, "Will my act harm other people?" Even if the answer is No, my act may still be wrong, because of its effects on other people. I should ask, "Will my act be one of a set of acts that will together harm other people?"[7]

For example, the ethical value of giving up eating meat isn't determined just by the act itself, but by the collective goal to which the act contributes. If everyone gives up eating meat, then even though my individual contribution doesn't matter much on its own, I may be ethically obligated to give up meat, because I'll be contributing to a greater good.

As you might imagine, the philosophical debate over collective action is lively and large. While I can't do the entire debate justice here, it's enough to take Parfit's semi-rhetorical question seriously. *Will my act be one of a set of acts that will together harm [or benefit] other people?* Partfit's presuming a "yes": everyone contributing their tiny share to bring about some good means I should, too. If the answer is "no," because there aren't enough other people acting to make a difference, it's hard to see how I could have an ethical obligation at all. To put it plainly, my act isn't one of a set of acts that brings about some greater good *if there isn't a set of acts.*

Here's an example that illustrates what I mean. Suppose that you and I ought to work together to lift a refrigerator in order to move it, because neither of us can do it on our own. It doesn't follow from the fact that *we* ought to work together to lift the fridge that you ought to try to lift the fridge if I don't lift the fridge. If I don't lift the fridge, you have a really good reason to bail. If you *suspect* that I won't even try to lift the fridge, you likewise have a good reason not to try. Philosopher Tobbjörn Tännjsö concurs, writing that while "it is perhaps correct to say that, under the circumstances, whenever the other one is doing his share I ought to do mine ... if the other one is not doing his share, I am under no obligation to do mine."[8] In other words, it makes sense to contribute to a collective goal only if we can be assured others will join us.

So, while there are many problems that can be solved only by collective action, and while we might think that *collectively* we have an ethical obligation to solve them, our collective obligation doesn't entail an individual ethical obligation without some guarantee (like a government policy or similarly powerful social mandate) that others will join us. The consumer in a social dilemma isn't obligated to give up something for the greater good out of her own initiative, *because there won't be good consequences* unless the institutions of society also act.[9]

Consumer boycotts of artists are social dilemmas. We need a lot of people to join in, because as individuals, we have no real power to affect successful artists. Just to give you a sense of the scale of the problem: according to *Forbes* magazine, Michael Jackson's lifetime, pre-tax earnings are around USD $4.2 billion. Someone who counted Jackson's money at the rate of a dollar per second, working twenty-four hours per day, would reach the end of his haul after 133 *years*. About half of his income has been made since his death in 2009,

including USD \$825 million in 2016.[10] Some of Jackson's wealth comes from the sales of his music, but the contribution of any individual fan to his wealth is small. If you stream a Michael Jackson song every day, by the end of the year you'll have given him almost four *cents*.[11]

If our decision to boycott an artist is to have any noticeable effect at all, many others will have to join the boycott. Without some assurance that others will join us, our individual calculation looks like this: give up a significant amount of aesthetic value for no benefit. Without any benefit, there's no reason to think we need to give up the artist's work, and no reason that we'd be ethically required to join the boycott.

Thus, in order to determine whether we need to join a boycott we must also consider whether consumer boycotts are likely to succeed. Here it doesn't look great. Most boycotts fail to bring about their aims. Ivo Welch, a professor of economics at UCLA, insists that boycotts seldom work. Famous successful boycotts are the exception, rather than the rule, and they typically succeed only when they happen to capture the political mood and coincide with other forms of protest, and the successful ones usually work through creating negative public attention rather than leading to drops in sales.[12] The boycott of Starfish Tuna over the deaths of dolphins caught in their nets succeeded not because the boycott crippled their sales of tuna but because the corporation had to act to preserve its public image.[13] Most of the time, however, boycotts fizzle out when participation is uneven. It would be reasonable to suppose that any consumer boycott of an artist would fail.

You might object that there are some reasons for optimism. None of us are attempting to boycott artists in a vacuum. Can't we be reasonably assured of viral success? While the #metoo movement isn't formally organized to the extent that King's

civil rights marchers were, what it lacks in organization it has in sheer numbers and ease of access. The #metoo movement is a child of social media; millions of women tweeted #metoo in response to Alyssa Milano's initial tweet. It's very easy to get involved; all you need is a smartphone. Social media also makes it easier to give a potential boycott clear communicative intent. If someone wants to announce that they're no longer engaging the artwork of immoral artists, they can announce it on social media and tag it (#metoo, #TimesUp). The tag makes it searchable by anyone interested in the topic, and social media posts can be reposted and shared. A boycott can gain critical mass via social media, as people see the tags and retweets and decide to join in.

As fans, we have more power than we might think because we can communicate our intent to boycott with little effort. We can influence others. If we decide that we're going to boycott all artists guilty of sexual misconduct, and we publicize it, we can reach many other people who might then follow our lead. Our decision to boycott can spiral up into a much greater effect than the small amount of money or attention we deny the artist.[14]

There are some problems with this argument. First, the Internet's attention span is notoriously fickle. The issues that grab our attention or go viral don't track the greatest problems or even the most effective solutions. Early in 2019, my personal bubble on the Internet seemed to be overrun by people debating the ethics of single-use plastic straws, which can't be recycled and typically wind up contributing to the ever-growing amount of plastic waste in the ocean. Straws don't make up the majority of plastic trash in the ocean; that dubious honor belongs to discarded fishing gear. If we wanted to reduce the amount of plastic trash in the ocean

significantly, we'd have been talking about eating less fish instead of tagging pictures with #stopsucking. Yet the straws, and the resulting debate over whether they should be banned, garnered far more attention that the real problem or its much harder solution.[15]

Second, the ease with which a hashtag propagates also means that it can be easily lost in a field of competition. You might have the best intentions, and the clearest case of an artist doing wrong, only to find that your attempt to boycott is flooded by memes of pumpkin spice, baby Yoda, or President Trump's latest Twitter gaffe. It's reasonable to believe that unless everything works out just right, most boycott attempts will drown in the sea of other demands on our attention.

Third, the most plausible causal chain that leads to a successful boycott means that the individual consumer matters *even less*. Too many things have to fall into place for a boycott to be successful. The artist has to be well known and appeal to people who use Instagram and Twitter. The hashtag has to trend. The trend has to catch the eye of someone with the actual power to affect the artist's finances significantly. While all that happens, no one can get distracted and lose focus. The success or failure of the boycott depends on not just finding enough likeminded consumers, but on hoping that the boycott catches the attention of media outlets and other institutions with actual power.

Finally, it's very hard to judge what is likely to go viral generally from what is likely to go viral in your online social circle. Nearly every philosopher I know on Twitter spent the good portion of a day in July of 2020 tweeting bad philosophy puns at each other, but the rest of the world quite reasonably really didn't care what a bunch of nerds found funny. We're limited by what we can see outside of our bubbles. If

our Internet bubble is really concerned about immoral artists, it's easy to overestimate how many other people would actually join in a boycott. The tags tell us who agrees with us but don't offer any evidence about what others think, or what they're likely to do.

Some boycotts will succeed, of course. The problem is that we can't tell in advance which hashtag-facilitated boycotts will win out. Here's where this leaves us. It's reasonable to believe, of any potential consumer boycott of an artist, that it will fail. If it's reasonable to believe of any potential boycott that it will fail, then the prospective boycotter's options are between continuing to engage with the artwork and giving up the artwork with no expected effect on the artist. Giving up the artwork would be powerless to affect the artist, and thus ethically pointless from the perspective of punishing them.

IV.

Let's turn to the second potential aim. Perhaps we aim not to punish the artist but to support their immediate victims. A consumer boycott initially seems promising. As casual fans, we're not in a position to offer much in the way of genuine solace, but at least we can make sure that the victims can see that everyone supports them when the artists' sales figures fall, and their fame dwindles. We can use the boycott to signal our support.

The trouble is that the problems of collection action all reemerge. Most boycotts will fail, and so fail to communicate anything to the survivors. We can stop engaging with the artist's work, but if we were far removed from the artists, we're even more removed than their usually far less famous victims. Our power as individual consumers is extremely limited, even though we wish it were otherwise, and the odds of a successful

boycott are slim. We wind up once again weighing the certain loss of aesthetic pleasure against the tiny contribution we'd make to an unsuccessful boycott. The survivors of high-profile cases of sexual assault and misconduct deserve support and respect, and to be treated with dignity. As fans, however, we're very poorly placed to provide that kind of personal support.

Moreover, not all survivors relish our support. Samantha Geimer, who was raped by director Roman Polanski in 1978 when she was thirteen, writes in her memoir that the obsessive, sensationalist focus on her case has harmed her more than Polanski did.[16] Geimer did what society says victims are supposed to do: she told her mother, and they went to the police. Polanski was charged in California with rape by the use of drugs, perversion, sodomy, lewd and lascivious act upon a child under fourteen, and furnishing a controlled substance to a minor; he pled guilty to a lesser charge of engaging in unlawful sexual intercourse. When he learned that his sentence was likely to include prison time, he fled to France, from where he would not be extradited.

His case has remained an endless subject of fascination, with renewed media interest every time he directs another film. People seem to have an endless appetite for this story. In 2008, the documentary film *Roman Polanski: Wanted and Desired* premiered at Sundance, and the grand jury testimony was published on *The Smoking Gun*. In 2009, Polanski was detained in Switzerland on the 1978 warrant and eventually released from custody.

Geimer's name was leaked to the press, which would have been damaging enough on its own, but every time Polanski is in the news, the media contacts her for commentary. Geimer is clear in interviews that what Polanski did was wrong, but she resents being criticized for failing to perform the role of

the forever damaged victim.[17] In 2003, she wrote an op-ed when Polanski's film *The Pianist* was nominated for an Academy Award (which it won), asking the members of the Academy to vote for movies based only on their artistic merit.[18] She has moved on with her life, refusing to allow it to be defined by one horrible night. She is resilient; that's a good thing.

Boycotting Polanski to support Samantha Geimer arguably would contribute to the lurid sensationalism of the press that can never quite leave her alone more than forty years after the assault. If you're boycotting Roman Polanski films to support Samantha Geimer, you're likely contributing to her pain, rather than helping to alleviate it. Because most boycotts are likely to go nowhere, the practical effect of your personal choices is close to nil to matter what you choose, but keep in mind that the moral valence of your decision to boycott is the *opposite* of what you intend.

More generally, we should resist the idea that whatever the victim decides is what we should do as fans. Victims aren't monoliths. Some might be willing to forgive and forget; some might just want to move on with their lives; others might want revenge. We should, of course, consider their wishes, but we should not delegate our responsibility to hold wrongdoers accountable to the victims. In any case, the best-case scenario is that in boycotting the artist, we contribute an infinitesimal amount of support to the victim; in the worst case, we harm the victim slightly to cast them in our play of outrage. Neither constitutes a good reason to try to support the victim of an artist by boycotting their work.

V.

Let's turn to the third artist-centered aim of a boycott. When a beloved artist is revealed to be a bad person, fans often feel

betrayed and even a little bit guilty. We feel complicit in their crimes. When we stream an artist's songs, for example, we contribute in a very small way to their success, and their success enabled them to harm their victims. For example, Jackson seems to have used his fame to groom his future victims. Some of the boys met Jackson when they were hired for his commercials and stage shows. One victim was a cancer patient who came to the Neverland Ranch as part of Jackson's charitable endeavors.[19] Enjoying Jackson's music is enjoying the work that enabled him to secure his next victim.

A similar case can be made for Weinstein, whose predation on actresses seeking parts in his movies was systematic. When we watched his movies, we contributed in a small way to his fame and power, and that enabled him to be in a position where he could rape women for years and get away with it. The story of the #metoo movement is a story of men whose wealth and fame made them unaccountable to anyone.

As a result, we might think that the aim of the boycott isn't to punish the artist but to avoid being complicit in their behavior. You might suppose that the arguments from the first discussion will apply here; find "punish," replace with "avoid complicity." But the problems don't quite share the same structure. The problem with boycotting someone to punish them is that our actions have no effect unless we're joined by others, and we don't have a reason to think that most boycotts will succeed. Boycotting on our own is therefore pointless. Here, the worry is that by continuing to enjoy their artwork we inadvertently do a small amount of harm, by being complicit in their wrongdoing, which we know has happened.

Enjoying artwork, however, isn't a direct harm. It's not as though listening to Billie Jean on Spotify harms a child in proportion to the amount of income we generated for Jackson.

Rather, we give the artist money (or attention) and engage with their artwork, and then the artist independently decides to harm someone else. We're causally connected to their wrongdoing, but a mere causal connection doesn't seem to be enough to make someone complicit in someone else's wrongdoing except in the most trivial sense. To put it another way, if streaming a song is sufficient to make us complicit in child abuse, whether or not to enjoy art is the absolutely least of our worries, as by those standards we are complicit in nearly every crime in our local communities by shopping at the grocery store. That's absurd.

To avoid the absurd conclusion, we need to tease out exactly what we mean by "complicit." To be complicit means to contribute in some way to someone else's wrongdoing and it has become a catch-all term for connections between people that seem to be morally dubious. Scholars Chira Lepora and Robert E. Goodin distinguish a few different ways that one could be complicit in someone else's bad behavior. One might *cooperate* together to plan and bring about a bad result. One might instead *collaborate* with them, where they choose and plan the bad result, and then help bring it about. One could *conspire* with them, planning the bad result without bringing it about. One might *collude* with them, trying to trick someone else into bringing them a benefit. One might *connive*, simply ignoring or quietly approving their wrongdoing while they commit it.[20]

None of these ways of being complicit apply to the casual fan. None of us helped Jackson get access to children. None of us helped him figure out how to use his fame to win the trust of the kids and their parents. None of us plotted to trick children into trusting him. None of us looked the other way while he brought children back to the Neverland Ranch. The

same can be said of our involvement in the misdeeds of other famous artists. As fans, we're not complicit because we are not in a position to help or hinder any of the artists.

Lepora and Goodin also identify one final way of being complicit in another's wrongdoing. One might *condone* their wrongdoing, by pardoning it and forgiving them. Note that condoning is the only sense of complicity that is fully after the fact. This seems like the only way that, as casual fans, we could be complicit in their wrongdoing. Here's the argument. By continuing to engage with the artwork of immoral artists, we're sending the message that we forgive them, or that we do not believe that what they did was bad. We're contributing to a message that tacitly says that what they did was OK, or forgivable, or at least not so severe that they should lose any market share. If we expect that stars are responsive to the so-called attention economy, they'll surely take our collective lack of response as a sign that their behavior must not be that bad.

Radzik observes that "where consumers have ample means and are presented with a broad array of products, purchasing choices may be perceived as expressions of their values."[21] It's common to think of many consumer choices such as fair trade coffee or ethically sourced chocolate as revealing what we care about ethically. We vote with our banknotes, and how we vote reveals what we value.

If that's right, then the reason we would have to boycott artists is that failing to boycott them would mean that we were condoning their behavior. Condoning their behavior is wrong, and crucially, it's a wrong that does not depend in any way on the actions of others. We each have the responsibility not to condone sexual assault and sexual harassment, even if everyone else around us does.

To evaluate this argument, we must consider whether a failure to join a boycott is equivalent to condoning their bad behavior. In general, contributing to someone's financial wellbeing itself is not equivalent to condoning all the choices that they go on to make. Suppose that we dine together at a fine restaurant, and we tip the server generously. Unbeknownst to us, the server loves to go out clubbing, but often behaves irresponsibly when it comes to getting home at the end of the night, regularly driving home while intoxicated instead of calling a ride. Even though we can imagine that, but for our generosity, she would not have had the money to go out, no one would say that we condone her actions just because we tipped well earlier in the evening. Mere financial support isn't sufficient to establish that we condone her behavior.

One might think that we bear no responsibility in that case because we did not know what she would do. We cannot condone something if we don't know about it. Let's then imagine that we return to the restaurant and overhear the server talking about her previous adventures giddily. The meal is again great, and we tip her generously again. It does not seem plausible that we're condoning her previous behavior by tipping her. Nor does it seem plausible that we're condoning her future behavior, even if we think it's likely that she'll continue to party after work. This suggests that as a general rule, exchanging money for goods or services does not mean that we condone everything that the person will do with the money. Merely causally contributing to someone's behavior doesn't amount to condoning their behavior.

There are other cases, however, where continuing to engage with someone after learning about some of their bad behavior would amount to condoning their actions. Imagine that you're the organizer of a local band night, and you have credible

reports that the lead singer of one of the acts you're planning to book serially sexually harasses groupies at the show. It's been a problem at previous appearances. If you know about the singer's harassment, and he knows you know, and you book the group anyway, it's plausible to think that he might take your decision to book him as implicitly condoning his actions. He might reason that if you had a serious problem with his behavior, you'd be in the perfect position to deny him the stage. Since you're still booking his act, he concludes that whatever problems you have with his conduct, they're not so strong as to preclude continuing to book him.

These examples suggest that in order for continued interaction with someone to count as condoning their behavior, our interaction has to communicate our approval to the person. In the case where you're booking the local band, it's plausible that the condition is satisfied. You had the power to decline to book him, and you didn't do it, and the lead singer can conclude that you wouldn't have booked him if you'd cared. In the case of the server even if we do not condone her behavior, we are still going to tip her properly due to norms about tipping. In the U.S., tipping is expected and failure to do so implies a negative judgment about the service. The server shouldn't infer from the fact that we were good guests that we approve of her drunk driving because there are other reasonable explanations for our continued interaction with her.

Is failing to boycott an artist more like tipping the server or more like booking the band? In some cases, continuing to engage with the artist could be perceived as condoning their behavior. Comedian Louis C.K. faced significant professional repercussions when it became widely known that he had masturbated in front of female colleagues on multiple occasions, including Netflix canceling a planned special, the

Orchard dropping distribution of his film I Love You, Daddy, and HBO removing his comedy from their streaming services. When Louis C.K. returned to the stage unannounced at The Comedy Cellar, the audience received him warmly. The audience's applause can be fairly read as signaling their forgiveness and their readiness to welcome him back. If one thought that Louis C.K. had not suffered enough for his actions, refusing to stand and applaud, or protesting his appearance, as some fans did when he returned a second time to The Comedy Cellar, would send a powerful message.[22] The fact that many of them didn't seems to be good evidence that they condone his return to the stage.

Most interactions between famous artists and their fans aren't nearly so intimate. Streaming a song or watching a movie does not communicate our approval to the artist. As individuals, we're simply too remote to communicate anything on our own. Moreover, there's a very simple alternative explanation of why fans engage with their artwork: they find doing so to be a meaningful part of their life. This simple explanation arguably has more power the more heinous the crime. Jackson still has fans; the billions of money his estate has earned since his death didn't come from nowhere. It strikes me as far more likely that by continuing to listen to his music, his fans communicate that *they don't believe the allegations against Jackson at all* or *there's nothing we can do about it now* rather than attributing to them the false belief that *sexually molesting children is no big deal*. It might be *wrong* or *foolish* to deny the allegations, and one can be fairly criticized for not believing victims, but they're not condoning child abuse.

Failing to join a boycott does typically not amount to condoning the artist's wrongdoing. Consequently, there is no ethical obligation to boycott an artist to avoid condoning

their wrongdoing. Listening to music, or watching a movie, or laughing at a comedy doesn't directly harm anyone and it doesn't condone the actions of those who do.

VI.

We have been considering the question of whether we are ethically required to boycott immoral artists to punish them for their misdeeds, to support their victims, or to avoid being complicit in their behavior. In all three cases, the answer is *no*. It's reasonable to believe that most consumer boycotts of artists are going to fail, and as a result, they will not successfully punish the artist or support the victim. It's telling that the artists who have been affected most by #metoo have been subject to forces much greater than fan boycotts. Some have been arrested, tried, and convicted. Some were fired when advertisers pulled their support, long before any fan boycott could have taken place. Most of the time, boycotts themselves are pointless, and ethics does not mandate making pointless gestures.

We've been very narrowly focused on the effect of the boycott on the artist, and in the next chapter, we'll expand our focus to consider what obligations we might owe to survivors of sexual violence, in general, or the broader community. There's a long way to go before we can conclude that it's OK to engage with the work of immoral artists. I want to close this chapter, however, by questioning the assumptions that made the case for boycotts possible.

We've taken it for granted so far that the right way to think about this question lies in calculating the consequences to the artist if we boycott their work, that something like *voting with our purchases* is the right way to capture the important ethical dimensions of this case. We imagine ourselves as

consumer-activists, whose primary way of interacting with the world ethically is by shopping and posting about it on social media.

Yet what a strange way to view the world! Imagine the following scenario: Michael Jackson is dead, and with the release of the *Leaving Neverland* documentary, his victims are finally being believed. Moreover, the 2nd Appellate Court has recently ruled that lawsuits brought by the victims against Jackson's estate will be permitted under the extended statute of limitations for sex abuse crimes.[23] If these lawsuits are successful, the victims will rightfully claim a portion of Jackson's estate as compensation for their pain. If the estate grows ever larger, the victims will stand to win more money. If we think Jackson's victims deserve the money, we should direct our entertainment cash toward Jackson, so that we can grow the pot as big as possible before the lawyers get at it. There is an ethical obligation to support victims of sexual assault, so we must support Jackson's estate with our purchases.

To be clear, this is not an argument that I would endorse! What it shows is that once we start evaluating all of our actions as consumers under the aspect of perceived tiny contributions toward a nebulous good, we can wind up with wildly counterintuitive conclusions. Better to conclude that consumer activism is a woefully limited way of trying to make sense of the culture-wide problem of sexual violence or the specific problems brought to light by the #metoo movement. We wind up as consumers trying to take on the burden that properly belongs to Hollywood executives and social institutions. It's not that the consequences of our actions don't matter; it's that focusing on consumer choices as the prime mover of social change is the wrong way to get a handle on the problem.

As consumers, we feel connected to the artists we love, but we're largely powerless to affect their behavior. They matter to us, but we don't matter to them. So, forget the artists. In the next chapter, we'll look at the argument that we should give up the artwork of immoral artists in order to improve how we, as a culture, treat survivors of sexual violence.

Why It's OK to Enjoy the Work of Immoral Artists

Three

I.

The #metoo movement started with Weinstein's arrest and Milano's tweet, but it quickly spread beyond the entertainment industry. Tagging a post with #metoo became a way for women who had no connection to the entertainment industry at all to share that they'd been sexually assaulted or harassed and find solidarity with other women who'd had similar experiences. Millions of women responded in a swell of cathartic anger. *That happened to me. I never told anyone. #metoo, #metoo, #metoo.*

Arguably, the #metoo movement drew its strength not because anyone cared greatly about the transgressions of artists, but because the problem of powerful men getting away with sexual assault and harassment resonated with the experiences of women. Survivors of sexual assault and harassment face a hard burden. The United States Department of Justice estimates that only 36% of survivors of sexual assault will make a report to the police. Of those who choose not to report to the police, 20% said they feared reprisal, 13% said that they believed it was a personal matter, and another 13% said they believed that the police would not help them.[1]

Sexual harassment is also distressingly common. A study conducted by the organization Stop Street Harassment concluded that 81% of women and 43% of men have experienced

some form of sexual assault or harassment, ranging from verbal harassment and unwelcome touching to being physically followed, flashed, and harassed online.[2] These incidents range in severity but all contribute to a pervasive culture where sexual assault and harassment are common. Survivors of sexual violence do not feel supported or safe.

The #metoo tag gave them the opportunity to share their stories, or simply add their "#metoo" to the growing tally. The #metoo movement occasioned a rare opportunity of public solidarity for those affected by sexual violence. It made it easier for them to come forward, and shaped the environment into one where, for a short time at least, they'd be more likely to be believed.

In a way, the #metoo movement isn't really about Weinstein or the other celebrities who were later accused. The artists and their stories are just the catalyst for what's feeling like a national reckoning, a change in the proverbial conversation about sexual violence.

I'm going to assume without argument that as a society, we desperately need to make it easier for survivors of sexual violence to come forward. I'm also going to assume that among the complicated reasons that explain why survivors don't come forward is that they do not expect a supportive environment, and that much of the time, they're not wrong. Given this context, the ethical implications of continuing to engage with the artwork of immoral artists seems to be less about communicating our disapproval of the artist and more about fostering a culture that is appropriately supportive of the survivors of sexual violence.

We discovered in the last chapter that most of the time, boycotting the artist has little to no effect on them, and so there's no ethical obligation to give up their work to try to

punish them. Here, I want to explore a different possibility. Maybe we're ethically obligated to give up the artwork of immoral artists in order to support the valuable project of changing the culture. Including the work of immoral artists in aesthetic projects signals that at the very least their crimes don't disqualify their work from our consideration; it signals that maybe we don't care that much about what they've done. That signal makes it harder for survivors to come forward. Continuing to engage with the artwork thus would undermine an ethical project in which we should participate.

In order to evaluate this argument, we'll have to look more closely at how engaging with immoral artists' work could undermine the attempt to improve the culture. I'll consider two arguments in this chapter. Here's a sketch of the first one. Boycotting the artist signals our support of the survivors of sexual violence to others. If we publicize that we're boycotting an artist due to their behavior, then we help define the boundaries of acceptable behavior. Continuing to engage with their artwork signals, on the other hand, that their behavior is within the bounds of acceptable behavior. Therefore, we should boycott the artist, so that we do not signal that we support such behavior.

Here's a sketch of the second argument. Survivors of sexual violence do not come forward because they believe that they will not be believed. They're not wrong to believe that, because our culture systematically discounts the experiences of survivors of sexual violence. We can counter that tendency by developing virtues as individuals that allow us to respond appropriately to survivors of sexual violence. Continuing to engage with the work of immoral artists, however, undermines our efforts to develop those virtues. Therefore, we should boycott their work.

I don't think either of these arguments succeeds *globally*. Neither of them makes a strong case that in general, we should give up the artwork of immoral artists. Both of them, however, encourage us to be mindful of how our aesthetic projects affect other people and our own ethical development, and provide support for the weaker claim that *sometimes*, we have to disengage from the artwork of immoral artists, or at least keep our enjoyment of their work on the down-low.

II.

Sometimes engaging with a work of art is a solitary act. We read works of literature silently, while sitting alone on a sofa. We listen to music with our headphones on so we don't disturb our roommates. We find a quiet afternoon when the museum is nearly deserted and the paintings are ours only to contemplate. In such solitary cases, the fact that we've chosen to engage an artwork communicates nothing to others about what we think of the artist because we communicate nothing about our aesthetic preferences all.

We should resist the temptation, however, to cast such solitary experiences as paradigmatic. Sharing characterizes our aesthetic lives. We share new songs with friends, bake cakes for parties, go to the movies with groups of friends, read books as part of a book club, attend a friend's performance in a play, worship in the cathedral, check out the new band at the bar, and many other experiences besides. When *Game of Thrones* first premiered, a friend and I made a weekly date to watch each episode together while we enjoyed cocktails and snacks. I crocheted and she did cross-stitch. For the finale of the first season, we attempted to make the lemon cakes beloved by one of the characters. (It was a mess. Note: make the cakes before starting on the cocktails.)

Social media extends the ways we can share our aesthetic experiences with others. By the time *Game of Thrones* ended, I had moved across the country. No more lemon cakes and stitching. A busy life and changing responsibilities meant that I streamed the episodes when I could, but I still texted my sister about the developments and speculated with friends on Facebook about which character would take the Iron Throne. My aesthetic experience of the show was never private, and much of the aesthetic value that I derived from the show lay in that I shared it with others.

The social nature that's characteristic of aesthetic consumption is arguably even more central to other aesthetic actions. When we curate or criticize or collect or teach, we act with others. A meaningful aesthetic project is often a shared aesthetic project. As a result, much of our aesthetic lives play out in public, and the artwork that we choose to engage affects others. The art we enjoy "says" something about us. Actions, such as enjoying art, can be treated as a kind of speech; in the U.S., the right to undertake symbolic protest such as burning a flag or wearing an armband is even grounded in the freedom of speech.

It's recognized that in spoken conversation, communication consists of more than the meaning of the words that one says. The fact that one chose to speak in the manner, place, and time that one did speaks volumes (pun absolutely intended). The philosopher Paul Grice famously proposed that there are rules of conversation that we usually intuitively obey such as "make your contribution as informative as is required" or "do not say that which you believe to be false."[3] These tacit norms govern conversation and allow us to communicate more than the literal content of the words that we utter.

When someone breaks one of these conversational rules, they wind up implying more than what they've strictly said.

Here's a variation of one of Grice's examples. Imagine that a university professor writes a letter on behalf of a student who is trying to get into an elite graduate program, and the letter says, "To whom it may concern: Ms. Grey attended my class on time, and her handwriting is excellent. Sincerely, Professor X." Everything the professor has said is true, but anyone reading it would conclude, "Ms. Grey is not a good candidate for this program." The professor has provided irrelevant information – elite graduate programs don't care about your punctuality or your handwriting – and so implies that he can't say anything better about the student.

Actions can function in a similar way. Suppose that you are introduced to someone new at a party, and (imagine this is before the pandemic, if you will) you shake his hand. Shaking hands, according to convention, communicates that you are pleased to make his acquaintance, or at least familiar enough with the convention of shaking hands that you know that it's polite to do so. Now imagine *refusing* to shake his hand. It wouldn't matter what your motives really were – you might have been distracted by a glimpse of tasty snacks or a friend across the way – your refusal would rightly be taken as rude.

When we engage with works of art publicly, we say (in this sense) a lot about ourselves. Our aesthetic tastes express our personalities and our values and provide some speculative evidence about other aesthetic tastes that we might hold, or what other aesthetic experiences we might like. Just as the person who accidentally refuses a handshake might be seen as rude despite their intentions, a man sporting a man-bun, wearing skinny jeans, and drinking kombucha is going to be pegged as a hipster, even if he doesn't think of himself that way.

In the context of the #metoo movement and its immediate aftermath, however, publicly engaging the artwork of

an artist conveys more than just one's aesthetic tastes. A radical change in context changes what an action conveys. As I write this, amid the COVID-19 pandemic, no one is shaking hands. There were brief attempts to replace the greeting with elbow bumps or toe taps, but mostly what we've settled on in my experience is an awkward extension of one's hand toward another, sheepishly retracting it, and making a fumbling remark about the coronavirus. Not shaking hands during a pandemic isn't rude, but prudent; someone who insists on doing so likely reveals something about their politicized beliefs about the severity of the pandemic.

Likewise, the attention the #metoo movement brought to the endemic problem of sexual violence means that publicly enjoying the art of immoral artists conveys that one doesn't take the problem of sexual violence seriously. If someone hosted a Woody Allen marathon and publicized it on Facebook several years ago, we might not give it a second thought, even if we weren't Woody Allen fans and even if we knew of Dylan Farrow's allegations. In the months following the #metoo movement, however, it is on everyone's mind. Publicizing that one is engaging with the artwork of immoral artists is likely to be taken, whether intended or not, as an attempt to send a message belittling the movement.

Similarly, *refusing* to engage with the artwork of immoral artists now sends a powerful signal, when a few years ago doing so might have been viewed as nothing more than a decision of aesthetic taste. Now, refusing to listen to Michael Jackson communicates something like *I believe the victims* or *continuing to listen to these artists is wrong*. Given the current context, engaging publicly with the art of immoral artists risks declaring that one does not care about the #metoo movement. The #metoo movement is polarizing (as we'll see in Chapter 5),

and engaging artwork will be interpreted in that light. As a result, there is a good practical reason not to engage publicly with the work of immoral artists. Other people very likely will think badly of you.

While it's clear that there is a pragmatic reason not to engage with the artwork of immoral artists, we need to do more to establish that there is an *ethical* reason to give up their work. Pragmatic reasons don't always track ethical reasons. If my boss announces that she wants us to wear purple shirts on Friday, I have a good pragmatic reason to keep her happy, but I don't have an ethical reason unless she has ethical grounds to mandate purple shirts. It might be prudent to wear a purple shirt, but not ethically wrong not to do so.

What we need, then, is a reason to think that the pragmatic reasons not to listen to artists amount to ethical reasons. Here are two. First, because everyone right now is talking about #metoo and immoral artists, survivors of sexual violence are having a rough time. They, like the rest of us, have learned about the artist's wrongdoing with shock and horror, but they're also likely to be bearing the burden of having to reprocess their own trauma. In that context, proclaiming that you're continuing to enjoy the artwork of an immoral artist is going to feel like an attack. Whether you intend it or not, you're going to be dismissing their pain and hurting them if you publicize what you're engaging.

Second, supporting the principles that #metoo has come to represent in the popular imagination – *believing survivors, supporting survivors, condemning sexual violence* – is a straight up good thing to do. If publicizing that one is still engaging the work of artists undermines those principles, especially in a moment where everyone is debating their importance, then we have an ethical reason *not* to engage their work.

We must weigh these ethical reasons against our aesthetic reasons for engaging with the work. This is a hard question to answer in general terms, because so much depends on the specific context and the specific audience. For example, in January of 2019, when the *Leaving Neverland* documentary aired, it was plausible to think that all things considered it would be both imprudent and unethical to include Michael Jackson's songs on a playlist for an elementary school dance. It would signal – whether you meant it that way or not – that you didn't take the allegations against him seriously.

That said, norms of behavior can change quickly. When I began this book, handshakes were an expected part of polite introductions. As I finish this book, handshakes have fallen out of favor due to the coronavirus, but by the time you read this book, they may be back in fashion, or they might not, or they might be irrelevant if we find ourselves in a *Fury Road*-style dystopia. Similarly, the perceived effect of engaging the artwork of immoral artists will change with time. By October 2019, Halloween advertisements running on the radio regularly featured the opening bars of *Thriller*. I noted the contrast between the furor in January over Jackson's music and the blithe use of the music in an ad but I was in the middle of a several-month-long project on what to make of the art of immoral artists. I doubt anyone else gave it a second thought. *Thriller*, and the associated zombie dance, and Vincent Price's laugh are part of the aesthetic tradition of Halloween. It's a spooky song about going to a horror movie, and it fits in with the holiday, with the Monster Mash, haunted houses, and small children fueled on sugar breaking the sound barrier as they tear around the neighborhood. In that context, the song almost seems like it has nothing to do with Jackson. Dancing to it at a Halloween party strikes me as signaling absolutely

nothing about the #metoo movement at all. As the peak of the #metoo movement recedes in time, the harm caused by the artists won't be on everyone's mind as much, and so publicly engaging the artwork will no longer seem like an attack on the movement.

Moreover, when weighing what we should do, we need to consider how important the artwork is to our aesthetic lives. For some of us, giving up an artwork amounts to giving up a small amount of aesthetic pleasure. I listen to a lot of music when I work, but most of it's in the background. I wouldn't like to work in silence but giving up an immoral artist for another artist wouldn't be much of a loss for me. For other people, however, the artists' work is integrated into their aesthetic lives. Giving up a source of value and meaning in the hope that doing so will communicate that they support the admirable aims of the #metoo movement is a much harder call. In most cases, it's reasonable to think that they're ethically in the clear if they continue to pursue their aesthetic projects, especially if they also publicize in other ways that they support survivors of sexual violence.

It's also important once again to distinguish between privately engaging with an artwork, semi-publicly engaging with an artwork, and publicizing that one is engaging with an artwork. Aesthetically appreciating a beloved artwork by oneself doesn't undermine the #metoo movement, because the act of appreciating doesn't communicate anything without an audience. Engaging with an artwork semi-publicly, as when one watches a movie with friends, can invite the implication that one does not care about the #metoo movement. In such cases, we have an obligation to be mindful that we cannot always control how our actions will be received, and so we need to be attentive to the composition of a group. Watching

a Woody Allen marathon with a group of close friends who are also fans, who have also wrestled with what to make of the man and his art, strikes me as less likely to harm someone than including R. Kelly on a playlist meant to be played a college social where odds are very good that in the crowd there will be survivors of sexual assault.

Publicizing that we're engaging with an artwork, however, seems like where most of the ethical problems will crop up. Here, I'm thinking mostly of broadcasting your aesthetic choices on social media. When everyone else is talking about the #metoo movement, going out of your way to list all the immoral artists you're currently enjoying seems like going out of your way to needle people. *Don't be a jackass on the Internet* seems like a good ethical rule of thumb, but it's also not one unique to the puzzle of what to do about immoral artists.

This is the closest I'll get to endorsing the idea that it's sometimes not OK to engage with the artwork of immoral artists, but I don't think there's support for a blanket ban on their work. Sometimes, the ethical and prudent thing to do will be to set aside their work temporarily or keep your aesthetic engagement of their work to yourself. Most of the time, however, it will be enough just not to flaunt what you're doing.

II.

The final candidate for the aim of a boycott that I'll consider here is that boycotting an artist can be a way to change the culture around sexual violence for the better. It's striking that many of the artists are serial predators, whose crimes were committed over many years. The earliest public accusation against Michael Jackson, for example, dates to 1993, when the son of a friend accused him of molestation, and the case was settled out of court.[4] The women coming forward in support

of the case against Weinstein are reporting incidents that are nearly thirty years old.[5] Cosby raped women throughout his fifty-year career.[6]

The crimes alone would be abhorrent had they been isolated incidents, whether occasions of spectacularly bad judgment or plain vanilla evil. Nothing should minimize that. Yet there's something remarkably evil about how ongoing and systematic their crimes were, and how they were able to get away with it. When we look at the cases, especially in light of the federal statistics, a pattern emerges. Many victims do not come forward because they believe with good reason that they will not be believed.

We could try to argue that we have an ethical obligation to boycott artists to improve the culture directly. Here's one way that could work. If we publicly stop engaging with immoral artists, we demonstrate that we believe the victims, and that what the artists have done is so wrong that it disqualifies their art from being the appropriate object of aesthetic appreciation. We'd help rewrite the norms of acceptable behavior.

Yet while improving the culture is a noble aim, trying to change a culture with a consumer boycott strikes me as the wrong way to characterize the attempt to improve the culture. First, all of the objections from the first chapter apply here. The actions of one person are not enough to change the broader culture, and we have reason to be skeptical of the success of consumer boycotts. One might object that #metoo has changed the culture concerning sexual assault and harassment. Yet we should keep in mind that the #metoo movement started with an indictment and a mainstream newspaper story; it's not clear what would have happened had the more traditional institutions of power continued to overlook Weinstein's behavior. More to the point, the culture

that inhibits survivors of sexual violence from coming forward has so much supporting it institutionally, such as police procedures, workplace harassment protocols, economic fears, educational deficits, religious and cultural teachings, and so forth that the prospective impact of even a successful boycott of artists seems small in comparison.

Moreover, giving up the work of artists alone does nothing to change the culture globally. No one will notice the artwork we give up unless we publicize that we're doing so. For some of us, broadcasting our aesthetic choices widely is part of our lives. Lots of us share our lives from breakfast to bedtime on social media. Yet it seems strange to say that we'd have an obligation to start publicizing our aesthetic choices widely if we aren't already inclined to do so. Imagine telling your film buff grandmother not just that she has to stop watching her copy of Chinatown but that she also has to create an Instagram account so she can announce to the world that she's putting it in the trash. (Or, rather, she doesn't even need to give up Chinatown; she just needs to tell everyone that she has. Realistically, no one's going to check.)

So, let's interpret "changing the culture" in a more promising way. Let's focus on the obligations that we have as individuals to make sure that we ourselves can be good allies of survivors. We need to change not the culture at large but our ourselves, and that's an aim that we can plausibly accomplish. We need to be the sort of people who are inclined to believe and support survivors. If doing so also happens to change the culture for the better, great, but we should do so even if all we manage to accomplish is affecting ourselves and our immediate social circle.

Let's set this up. Not being believed often results from injustice. Philosopher Miranda Fricker has identified *epistemic*

injustice as a kind of injustice that occurs when we wrong someone "in their capacity as a knower." We don't treat them as someone who has knowledge ("epistemic" comes from the Greek for "knowledge"), which means that we don't take what they say appropriately. Understanding how epistemic injustice works will explain why victims of sexual violence are loath to come forward.

There are two kinds of epistemic injustice, testimonial injustice and hermeneutical injustice. *Testimonial injustice* occurs when we wrong someone by discounting what they have to say unjustly. When someone tells us something ("gives testimony"), we decide how credible we find them. "Credibility" tracks how likely we are to believe what they say. We base our judgments of credibility on our knowledge of the person as well as many other factors. We'll judge the credibility of the doctor in matters of medicine to be higher than the credibility of someone who relies on Dr. Google. The villagers who ignore the cries of the boy who cried wolf *downgraded* his credibility because of his history of lying about wolf sightings. Assigning credibility to speakers is something we do all the time, without being aware of it, and it's a natural and often blameless part of participation in everyday conversation.

Prejudice can unjustly affect how we receive someone's testimony.[7] Fricker writes, "[e]ither the prejudice results in the speaker's receiving more credibility than she otherwise would have – a *credibility excess* – or it results in her receiving less credibility than she otherwise would have – *a credibility deficit*."[8] Fricker draws on two examples from fiction that illustrate how credibility deficits lead to testimonial injustice. In *To Kill a Mockingbird*, lawyer Atticus Finch demonstrates that his client, Tom Robinson, cannot be guilty of assault, because Tom's disability, a crippled hand, meant that he could not have

inflicted the injuries he is accused of causing. In the fiction, his argument is presented as one that should be convincing. Robinson, however, is a Black man in the deep South, and the jurors refuse to believe his testimony in his own defense, simply because of who he is.[9]

Similarly, in the screenplay *The Talented Mr. Ripley*, Marge's suspicions that Ripley has murdered her fiancé Dickie are brushed off by Dickie's father, who waves off her concerns as merely women's intuition, not facts.[10] In both of these cases, Fricker argues that the credibility deficit leads to testimonial injustice. Robinson's words aren't believed because of who he is; a Black man's word in the Jim Crow Era can't defeat a white woman's accusation. Marge's correct beliefs are dismissed for no other reason than her gender.

Credibility excesses occur when someone's social standing makes them more likely to be believed than they otherwise would be. Dickie's father *should* have less credibility than Marge; she knows both Ripley and Dickie better, and she knows that Ripley now possesses a ring that Dickie swore he'd never remove. He benefits, in the story, from being an older white man, and so his beliefs are treated as credible while hers are not.

Most real-life examples of testimonial injustice aren't as extreme as the fictional cases, where Robinson and Marge are not believed because of prejudice. It's more common that testimonial injustice makes someone *less* likely to be believed than they should be.[11] Realistic examples are easy to imagine: a person who uses a wheelchair finds that other people treat her as though she is mentally incapable of understanding them despite her speaking to them clearly and confidently; a jury that assumes that a Black defendant is lying; a professor who ignores the suggestion from the Latina woman in the

seminar until the suggestion is made loudly by a white man; a young man from Tennessee who finds his native accent makes people assume that he's mentally slow. We don't need to postulate villainous behavior, just commonplace human frailty that makes us a little worse than we should be when we listen to other people.

The second kind of epistemic injustice, *hermeneutical injustice*, leaves its subject without even the concept to explain that what happened to them was wrong.[12] Consider the workplace environment depicted on *Mad Men*, a television drama set in the early 1960s at a Madison Avenue advertising firm. Actions and behaviors that we now recognize as sexual harassment were not recognized as a *thing*. Women might have thought that their boss was handsy or a creep, but they wouldn't have yet had the language to identify that what they were experiencing was sexual harassment, because the broader culture hadn't yet grasped the concept. We can explain the false but plausible-sounding claim that "sexual harassment didn't exist in the past" as an acknowledgment that the concept of sexual harassment was not yet part of our social imagination in the past, so women who experienced bad treatment had no way to conceptualize it or communicate it to others. Hermeneutical injustice silences victims because its presence means that the concept they need to express how they were wronged isn't available.

Testimonial injustice and hermeneutic injustice are useful concepts for understanding the #metoo movement. Children and women often face credibility deficits. Children's testimony is dismissed because of their youth and inexperience, and the popular belief that they are easy to manipulate into lying. Women are generally presumed to be prone to lying about sexual assault, either to preserve their reputation or to

avenge themselves on a former lover.[13] Our culture also has the idea of the "casting couch," where budding starlets exchange sexual favors with movie producers and directors for roles in films, "teenaged groupies," who want to have sex with rockstars, and the general loose morals of anyone involved in the entertainment industry.

We can see the credibility deficit at work in Jackson's 2005 trial for molestation. Jurors' statements to the media after the case focused on the mother of the boy who made the accusation. The New York Times reported that one said that she believed that the mother had "taught her children to lie to gain money or favors from celebrities"; another answered affirmatively when asked whether the mother was a scam artist. She had lost "the jury with her rambling, incoherent, and at times combative testimony," argued with Jackson's lawyer, and lectured the jury.[14] The American judicial system is adversarial, so it is expected that the defense will use whatever it can to cast doubt on the prosecution's story. What's interesting for our purposes is the choice; of all of the ways to defend Jackson, the successful one attacked the mother as a conniving con artist and the children as liars.

Some of the celebrities in the #metoo movement also unjustly benefit from an excess of undeserved credibility. Jackson was a beloved wealthy pop star whose charities included Heal the World and the Make-a-Wish foundation.[15] While fans thought of him as eccentric, he was also thought to be childlike and innocent, someone who connected with children because his own childhood had been stolen from him by the early fame of the Jackson 5.[16] It's reasonable to think that prior to what we know now, Jackson benefited from an excess of credibility. People believed that generous, wealthy, and popular celebrities don't harm others; if anything, they

have to take precautions because they are targeted by those who would prey on their lies.

It's also plausible that the entertainment industry was slower than some in recognizing boorish behavior as sexual harassment, contributing to hermeneutical injustice. Louis C.K. said in a public statement that he didn't think that masturbating in front of his women coworkers was wrong because he had asked permission. He was seemingly unaware of the bizarreness of such a request, or that given his position of relative power and fame, the aspiring comics working with him might not have felt like they could reasonably say no.

Here's a plausible way to recharacterize our proposed boycott in terms of epistemic injustice. We recognize that both testimonial injustice and hermeneutical injustice exist in our conversations about sexual misconduct. Survivors' claims are routinely dismissed or minimized, and this results from deepseated structural prejudices in our society. Some survivors will censor themselves if they believe it's futile to speak up, or if they cannot successfully communicate that what happened to them is wrong.

Given what we've learned here, it is reasonable to believe that epistemic injustice concerning sexual violence is widespread. Moreover, it's likely that everyone reading this book unwittingly contributes to epistemic injustice. That's not because we're all extraordinarily depraved, but just because we're human. We are often not blameworthy for the fact that we have allowed prejudice to influence our judgments because we came by the prejudice innocently, perhaps as children, or through lack of exposure to different cultures. Nevertheless, once we've identified epistemic injustice, and recognized that we contribute to it, we must root it out.

So what should we do? Fricker argues that given the existence of testimonial injustice, we all incur an obligation to develop the virtue of *testimonial justice*. Testimonial justice is a corrective virtue; it fixes character flaws. Someone who possesses testimonial justice will have trained themselves to correct for prejudice tied to someone's identity so that they can give their words the appropriate weight. Likewise, there is a corresponding virtue of *hermeneutical justice*. Someone who possesses hermeneutical justice will not dismiss a speaker just because they struggle to make sense of their experiences.[17]

Recognizing the virtues of testimonial justice and hermeneutical justice is comparatively easy; developing these two epistemic virtues is harder. Both ancient Greek and ancient Chinese philosophers wrote on the cultivation of virtue, and we can look to them for advice. The first thing we need to do is recognize what we need to work on. The classical Confucian philosopher Xunzi wrote about the cultivation of virtue, saying "when you observe goodness in others, then inspect yourself, desirous of studying it. When you observe badness in others, then examine yourself, fearful of discovering it."[18] For us to develop the virtues of epistemic justice, we first need to recognize how we inadvertently contribute to injustice. We should notice and consciously recognize how prejudice affects our judgment of other people's credibility. We risk unjustly deflating the credibility of other people if we do not correct for our prejudices. Second, we must recognize that who we are affects how others speak to us. Our position in society and our perceived power affects how other people perceive us and what they are likely to communicate to us. We risk silencing people when they judge that we are not the sort of person who would be sympathetic to what they say.

But how, exactly, do we improve? According to the ancient Greek philosopher Aristotle, and the virtue-centered ethicists who have followed his lead, becoming virtuous is a matter of developing virtuous habits by undertaking virtuous actions. One isn't virtuous unless one has made a habit of undertaking virtuous actions. For example, giving to charity is a *generous* action, but one is a *generous* person only if one consistently performs generous actions. To be truly generous takes time and repetition. In a phrase: fake it till you make it.

If we are to develop the virtues of testimonial and hermeneutical justice, we need to practice corrective measures aimed at eliminating prejudice in ourselves. This might take many different forms: reading non-fiction about others' lives and perspectives; educating ourselves about sexual assault and myths; talking to others with different experiences; learning how to present ourselves as trustworthy through our behavior. Philosopher Elizabeth Anderson argues we also need to stress structural remedies, in part so that individual virtue has a chance to operate. We often find ourselves without knowledge of exactly where we might have gone wrong, or what would have been the best thing to do to correct it.[19] That said, developing the virtue remains an individual responsibility; it doesn't matter what other people choose to do.

Here's the question for this chapter. Is engaging with the work of immoral artists compatible with developing the virtues of epistemic justice?

Here's the case for "no." Developing the virtues of epistemic justice is a difficult project that will take consistent effort over many years. To do so, we'll need to work within a culture that consistently undermines the credibility of victims. We'll also need to work hard to listen to victims without discounting what they're saying, and we will need to recognize the extent

to which our social identities and position can silence victims. Given the importance of the virtues, and the challenge that developing them represents, we cannot afford to undermine our progress.

It's plausible to think that enjoying the artwork of an immoral artist might hinder the development of the virtues. In general, we are not always very good at separating the art from the artist (more on this in Chapter 4). We tend to ascribe character traits to actors that belong to the characters that play them. Actors who play creepy characters risk getting typecast; actors that play doctors risk getting asked for medical advice. Moreover, we conflate the emotional responses we have toward art with the artist. If we love the art, we find ourselves positively inclined toward the artist. If we are positively inclined toward an artist in such a way that makes us more likely to inflate their credibility, then when we engage with their art, we inflate their credibility a tiny amount. Thus, we should not engage with the works of immoral artists, because doing so will unjustly improve our attitudes toward them. Engaging with their artwork will make us more susceptible to epistemic vice.

One problem with this argument is that it applies too broadly. If we generally fail to separate the art from the artist, then we will find ourselves unjustifiably positively inclined toward any artist whose artwork we like. We'd have good reason never to engage with any artwork whatsoever, lest it make us more likely to trust the artist, who of course at any point could go on to commit morally objectionable acts. I suspect no one would want to endorse a world without any kind of art just to avoid the risk of slightly inflating the credibility of an artist.

Yet I think this argument misses the mark in another way. We all should develop the virtues, but since ancient times,

in both Greek and classic Chinese philosophy, it's been recognized that the method by which one develops the virtues will depend on the individual's temperament and circumstances. Here's an example. Imagine taking two friends out on a technical mountain biking trail. As an experienced biker, you know that getting down the trail requires a measure of courage. One must stay relaxed and loose to remain in control over the roots and rocks. Your friends are newbies and look to you for advice on how to approach the hill. One is a daredevil who charges ahead without thinking; you tell him to approach the descent cautiously and use his brake to slow his approach. The other is more timid; you tell her to get off the brake and attack the trail. You haven't contradicted yourself. In both cases, the end goal is the same: a ripping but controlled ride down the hill. You've just tailored your advice to fit the personalities of your friends to achieve that end. Giving them the same advice would result in disaster: your reckless friend would lose control due to excess speed, and your timid friend would crash through an abundance of caution.

The conclusion that we can draw is that the requirement to develop a virtue doesn't entail the method. Boycotting the art of morally troubling artists is not the virtue. It's the *means* for developing the virtue, and specific means are rarely mandated when it comes to developing virtue. We are required ethically to develop the virtues of epistemic justice, but the means by which we develop that virtue depends in part on our individual temperament.

If you're the sort of person who tends toward overzealous, fawning fandom, the pursuit of epistemic justice might require you to take a step back from engaging with immoral artists. If you have a hard time distinguishing between the persona the artist creates and the person in real life, then you

have a personal reason to refuse to engage their artwork. You're the kind of person who is likely to let your positive feelings about the artwork bleed over into inappropriately positive feelings for the artist. If you find yourself making excuses for the artist even when you have good evidence of their crimes, you need to step back. Your love of the artist is leading you to whitewash their crimes. There's a case to be made here for a good rule of thumb. If you're not sure whether you can pursue epistemic justice and continue to engage with art, then set aside the artwork for a bit.

For many of us, however, developing the virtues of epistemic justice forms part of one of many projects we set for ourselves. We want to be better people, and we also want to pursue rich, full, aesthetic lives. We might think that the safe course is to try to be morally perfect, such that every action that we take develops a virtue. To maximize the development of the epistemic virtues, we should boycott immoral artists. This strikes me, however, as too strict. We have many virtues that we need to develop during our lives, but we are under no obligation to maximize our development of them by going to extremes. We must develop our intellect, but we're not necessarily doing something wrong if we take time away from studying to relax by playing Mario Kart.

Being ethical is part of a good life, but so are other pursuits. The philosopher Susan Wolf developed the idea of the moral saint, someone who perfectly embodies the recommendations of ethical theories. They have only one aim: be as moral as possible. As it turns out, the life of a moral saint, while morally admirable, does not seem to be desirable at all.[20] The television show *The Good Place* dramatized the idea of a moral saint through its character Doug Forsett. *The Good Place* follows the adventures of four people who wake up in the afterlife.

They're told initially that they are in "the good place," but we learn in the first season that they are part of an innovative new project in Hell, where they are to torture each other. They are in the bad place because they did not accrue enough good points through their actions in life. As the show develops, the main characters decide that they will learn how to be better people so that they can rightfully get into the good place.

In one of their adventures, characters eventually meet Doug, the one person who figured out how the afterlife worked. His only care is to maximize his ethical life to accrue as many points as he can. He has no other projects. Doug evaluates every action of his through its effect on others, and so eats only wild lentils and radishes he cultivates himself so that he might not inadvertently harm anything. He cries when he accidentally kills a snail and honors it with a lavish funeral.

Here's the twist: Doug's life is *miserable*. His obsessive focus on perfection left him with nothing that resembles a good human life. This is Wolf's point; no one should want to be a moral saint, because we value other goods in life besides those that can be comfortably folded into morality. We want to watch movies, even though we could have donated that money to charity. We want to learn the oboe, even though the time and effort spent could have more productively served society in other ways. We need to be good, but we do not need to do so at the expense of a well-lived life.[21]

Our aesthetic projects are part of a well-lived life, too. Sometimes these projects incorporate the works of art beyond mere appreciation and enjoyment. Imagine a former touring rock musician who after retirement decides to pass on his love of rock music by opening a *School of Rock*-style music studio. He and his fellow teachers teach all manner of musical instruments and styles, including guitar, drums, and voice. To

do his job, he needs not just to listen to rock music, but to understand its history and trace its influences.

Many classic rock musicians behaved very badly toward women by 2019 standards; many of them would have been easily targeted by the #metoo movement had they been active today. [22] The studio owner, like all of us, needs to develop the virtue of epistemic justice, but while it's conceivable that giving up the work of rock musicians would help him do that and that doing so would be a meaningful statement, it's not plausible that he's required to do so any more than he needs to eat only radishes to save the planet. He can develop the virtues in another way while retaining his aesthetically valuable project. He can condemn the behavior and lifestyle of musicians while teaching youngsters to shred.

To complicate matters further, engaging with art can aid us in our duty to develop the virtues of epistemic justice. Some art allows us to experience glimpses of other lives, giving us the chance to understand the perspectives of others. The cost of boycotting artists sometimes includes the loss of the moral messages of their artwork and the potential for ethical growth that represents. I'll take up this question in more detail in the final chapter, but for now, it's enough to say that any decision to boycott an artist should also include considering the ethical benefits of continuing to engage with their work. Thus, while we need to develop the virtue of epistemic justice, there are many ways we could accomplish that, and many of them are compatible with enjoying the art of immoral artists.

The ethical requirement we've uncovered in this chapter is to develop the virtue of epistemic justice. The mechanics of how that virtue gets developed will vary, and most of the time won't forbid pursuing our aesthetic projects. As a casual fan, my decision to engage doesn't matter all that much to the

finances of the artist, and similarly, the decision I make about their artwork probably factors only in a small way to my pursuit of epistemic justice. What matters much more for me, as a college professor, is whether I develop habits that help me listen to my students, that I work to free myself from prejudice, and that I encourage fairness in departmental and university policy. The ancillary effects of the aesthetic projects I pursue are dwarfed by all the other decisions I make every day.

Most of us can develop the virtues of epistemic justice while pursuing our aesthetic projects, even when the artwork at the center of the projects was made by horrible people. The requirement to develop the virtues of epistemic justice, while it requires us to improve ourselves, does not preclude enjoying the work of immoral artists. The need to develop virtues should not condemn us to an aesthetically impoverished life, and ultimately we decide which aesthetic projects to pursue.

So where does the overall case stand after two chapters? We can say that while it's ethically permissible to give up the artwork of immoral artists, the main reasons that we might have thought that we *had* to give them up don't hold up to scrutiny. We're absolutely right to condemn the artist's behavior, but as it turns out, a consumer boycott isn't really a great way to do that. We absolutely need to develop the virtues of epistemic justice, but most of us can do that while continuing to enjoy great art. We have more ethical questions ahead of us, but for now, it looks like it's OK to enjoy the art of immoral artists.

Four

I.

Of all the memories of Cosby's work woven through my childhood, the image of Claire Huxtable dancing through the credits of The Cosby Show in a swirling peach gown inexplicably remains the most vibrant, but it hardly stands alone. I learned the rudiments of budgeting from Cliff teaching Theo. From my parents' vinyl collections of Cosby's comedy, I knew what it was like to drive in San Francisco before I had a license. I learned that Noah's ark blocked the driveway in his subdivision. We gave my dad a copy of Cosby's book Fatherhood one Father's Day. I read it and learned that the secret to being a good dad was loving your kids so much that your heart ached.

We now know that Bill Cosby, the man who was goofily selling pudding pops, collecting Black art, and donating millions to historically Black colleges and universities, who was "America's Dad," drugged women and raped them, serially, systematically, throughout his entire career. The man whose signature character once lectured his son-in-law on the importance of feminism has been convicted of rape.

I find that I can no longer endure Cosby's comedy. I can no longer watch or listen to his comedy without his crimes immediately intruding, thinking that while he was joking around, snuggling Rudy, doing Julia Child impressions while making soup, he probably had Quaaludes waiting backstage

for his next victim. I am surprised at the strength of my own feelings. It probably comes as no surprise, given the subject matter of this book, that ordinarily I do not find it hard to separate the artwork from the artist. Many of the great artists of history were horrible people in their private lives, but most of the time I find it relatively easy to set their artwork to one side. I can't bring myself to take Carvaggio's murderous temper or Beethoven's arrogance as much more than the answer to potential trivia questions. Even when the artist is a contemporary, I usually find it pretty easy to distinguish between the good the art represents and the evil the artist did.

I'm not alone. When fans defend themselves from the insinuation that they should stop enjoying their favorite artworks because of the misdeeds of the artist, they often appeal to the claim that artwork is separable from artist. The artist themselves is to be deplored for their bad deeds, but those bad deeds don't, or shouldn't, affect how we experience the art. Learning that the person who created an artwork was deeply flawed should not affect whether it's ethically acceptable to continue to engage with it.

We saw in the first chapter that this response is too quick. There are many potential ways that continuing to engage with the artist could be ethically wrong, and they need to be taken seriously. Yet after investigation, we've shown that most of those proposals, while initially plausible, don't succeed. Most of the time, it's OK to enjoy the artwork of an immoral artist.

Still, we might wonder about the cases where it seems much harder for us to separate the art from the artist. In those cases, we might wonder why we should feel such resistance if it's so easy to separate art from the artist. Are we guilty of a mistake if we separate the art from the artist? Are we guilty if we don't? Thus, in order to see whether we can separate the

ethical flaws of the artist from the artwork, we need first to think about how ethics and art typically intersect.

Ethics is the philosophical science that concerns how we ought to live, and its subjects range from analyzing hard practical situations to more abstract considerations about the nature of goodness. (One important caveat: how we determine what counts as ethical behavior in general is a hard task, and one that's simply too big for a book of this kind. I'm not going to try to adjudicate all of ethics in this book. For our purposes, commonsense ethics will be enough.) We evaluate something ethically when we consider its ethical impact. One might be tempted to think that art stands alone, immune from any ethical controversy, because art stands apart from other kinds of experiences. Art for art's sake, and all that. But that's not right. Artworks can be properly the subject of ethical evaluation. They can be ethically good or ethically bad.

There are many ways that an artwork could be ethically bad. A forgery is ethically bad because the artist who produced it passed it off as someone else's work, usually for financial gain. An artwork that unethically appropriates someone else's culture harms the community from which the artist stole the idea. An artwork whose creation involved harming others would be unethical. It's common to evaluate art from an ethical perspective, and to use the language of ethics to describe it. Art is no more immune to the ethical consequences of decisions than any other aspect of our lives.

Art also can be ethically evaluated by how it portrays ethically significant matters. If an artwork endorses an ethically praiseworthy attitude, then we can say that the work is an ethical work of art. If an artwork endorses an unethical attitude, then it's unethical. Note that we should be careful here to distinguish between merely *depicting* something that's immoral

and *endorsing* an immoral attitude. The Legacy Museum in Montgomery Alabama features many artworks whose subject matter is slavery and lynching. Slavery and lynching are great evils, but the artwork isn't evil for depicting them, for it depicts them correctly *as evil*. A work that celebrated slavery, by contrast, would endorse an evil attitude, and so would be ethically wrong.

The aesthetic question typically asked by philosophers of art is whether an artwork's ethical stance makes it better or worse as a work of art. Most philosophers fall into two camps. The first position, *autonomism*, says that our aesthetic judgment of a work of art should be wholly independent of its ethical qualities.[1] Art should be judged as art, and not as a morality play. Being morally suspect doesn't automatically make a work of art less aesthetically valuable and promoting a moral point of view doesn't automatically make a work of art more aesthetically valuable. The autonomist recognizes that art can be moral or immoral because art can and does often take a stand on moral questions.[2] They just think that the morality of the artwork is irrelevant to judging it as a work of art.

There's some appeal to this kind of position. Works of art are often judged by whether they adhere to a list of ethical or political standards rather than whether they're artistically any good. We can see this in pop culture discussions of films like *Wonder Woman* or *Black Panther*.[3] Both films were more-or-less standard superhero action films, delightful and appropriately full of cinematic explosions, feats of superhero strength, and bad guys, but much of the public discourse around them focused on the feminist messaging in *Wonder Woman* and the lack of racial diversity in mainstream blockbusters that *Black Panther* partially rectified by featuring a nearly entirely Black cast. The autonomist can grant that both movies have a positive ethical

valence but still think that the question of whether the movies promote good messages has nothing at all to do with whether they were any good *as movies*. What made Black Panther a good superhero movie, the autonomist might say, had to do with its stunning aesthetic vision of an Afrofuturistic utopia, the charisma of the lead actors, and an outstanding villain; its worthy ethical qualities are entirely beside the point.

The difficulty with autonomism is that in some cases the ethical standpoint that a work presents affects whether it is aesthetically successful. The film *Triumph of theWill* was an amazing achievement in the craft of film. Director Leni Riefenstahl pioneered new film techniques that one can still see used in films today, eighty years later. Yet many of us would not find it to be an aesthetically successful film, because the glorious shots of the city peeking through the clouds, the view from the back of a motorbike of the crowds lining the streets, the scenes of happy children excitedly cheering were all in service of the Nazi regime. The film was propaganda for Hitler. To most modern viewers with knowledge of history, the effect of the film is chilling rather than thrilling.

The autonomist has to say that our knowledge of the evil of Nazism should not factor at all into our aesthetic evaluation of the film. The autonomist isn't denying that Nazis are evil, or that *Triumph of theWill* endorses an evil attitude. Rather, the autonomist says that the aesthetic value of the film isn't affected by the film's evil attitude, and the aesthetics are all that matters if we're judging the work's success as an artwork.

By contrast, *ethicism* would say that a film's moral attitudes can be relevant to aesthetic evaluation in some circumstances.[4] *Triumph of theWill* is supposed to leave the viewer excited and favorably disposed toward the Nazi regime, but for a modern viewer, the film is a surreal experience. The bold swastikas

draped over buildings are jarring. One can't appreciate the aesthetics of the film as cinema because one is continually reminded of the atrocities of the Second World War, which began four years after the film was completed. Scenes of children giving flowers to Hitler, intended by Riefenstahl to be charming, read as sinister. The film prescribes that the audience should take a positive attitude toward the Nazi regime, but most of us find that impossible to do. As a result, modern audiences can't engage the work as Riefenstahl meant. The film fails to achieve one of its aesthetic goals – to get the audience of the film to feel a certain way about Hitler – and because of that, it's aesthetically flawed, just as it would be flawed if it tried to evoke sadness but instead was so melodramatic that it instead made us laugh.

The problem can be generalized to include any work of art that endorses an unethical point of view in such a way that it interferes with us engaging with that work of art. Note carefully that the ethicist position doesn't entail that any work of art that endorses an immoral point of view is aesthetically flawed. If a work succeeds in getting the audience to play along with its evil, it will be aesthetically successful. If the ethical flaw in the work stops us from engaging with the work, then it's an aesthetic flaw just like any other feature of a work would be if it stopped us from engaging with the work. Think of ethicism as setting a high bar for works that play with an unethical point of view.[5] It's not hard to get an audience on board with thinking that puppies are cute and should be cuddled; it's much harder to get an audience to think that a meth kingpin who destroys his family and betrays his friends, as portrayed in the television series *Breaking Bad*, deserves a happy resolution. An ethical flaw is a small mark against the success of a work, but the work might be on balance successful.

Note that both autonomism and ethicism focus on the ethical content internal to the work: what the work endorses or rejects. The philosopher Christopher Bartel has suggested that ethicism can be extended to include the ethical flaws of the artist.[6] All artists are ethically flawed because they're human and no one is perfect. Sometimes the artist's ethical flaws, however, make it impossible for us to engage with their artwork. This seems to be a plausible suggestion. If someone's crimes make it impossible for former fans to enjoy their work, then their work no longer is aesthetically successful.

Yet the suggestion to extend ethicism to include the artist raises two more questions. We need to figure out why some ethical flaws give rise to aesthetic problems and others don't. If Cosby had been indicted for tax evasion, I suspect most of us would be pretty surprised, but we probably wouldn't feel much pull to re-evaluate his work. Moreover, whether an ethical flaw leads to an aesthetic failure does not seem to track the seriousness of the artist's alleged abuses reliably. Otherwise, people would not feel torn about whether it's ethically acceptable to continue to listen to Michael Jackson. Instead, they would find it relatively easy to reject his music, but that's not what we see. We need an explanation of the mechanism. What goes on in our brains when we find it hard to separate the art from the artist's wrongdoing?

The second question we might have is normative. We might wonder if we are ethically required to re-evaluate some works as ethically flawed. Let's put this question plainly. Suppose I have no problems continuing to watch The Cosby Show after learning of Cosby's conviction. I repudiate his crimes, of course, but when I watch the show, I feel no strong sense of revulsion. I laugh as I used to, as if nothing happened. Is that

reaction right, or should I aim to be the sort of person who can't separate the art from the artist?

II.

One explanation for why it seems so hard for so many to separate Cosby's artwork from Cosby the man is that his most famous performance was *The Cosby Show*. Most of Cosby's comedy presents admirable ethical attitudes. Cosby's comedy is soft, warm, and non-threatening, by design; Cosby, as a trailblazing Black comedian, had to be palatable to white America if he wanted to succeed. *The Cosby Show* starred him as an upper-middle-class doctor, a graduate of a historically Black medical school, married to a successful lawyer, surrounded by a gaggle of adoring adorable children and later grandchildren. As Cliff Huxtable, Cosby is a supremely involved father, simply being *around* for his family. Most of the wit of the show presupposes a keen sense of observation of the dynamics of family life. Huxtable wants his kids to leave home so he can have some well-deserved peace and quiet, but not so much that he really wants them gone.

He was the perfect dad. He was America's Dad, who held his kids to high standards but always with love. Someone who took parenting advice from his comedy would do just fine, and arguably would be better off than someone who took advice only from published parenting guides.

Cosby's comedy never defended rape. One can only imagine Cliff's horrified reaction to such crimes. If ever the artist was separate from his art, Cosby surely should be such a case. Yet something is puzzling about Cosby in particular. While writing this book, I've had many informal conversations about artists and the #metoo movement. People's reactions when learning about the misdeeds of their favorite artists vary, but

if I had to generalize, most seem to be willing to continue to engage with the art of artists that they liked a lot, and willing to give up the work of artists for whom they were lukewarm. People seem willing to overlook a lot to keep engaging with an artist that they love. Cosby, however, seemed to be an exception to that rule. Many reported having grown up with *The Cosby Show*, but also that after learning of the accusations, and his eventual convictions, that they were done with him and his work. There often seemed to be a sense of betrayal or anger toward him, for misrepresenting himself.

We might wonder why it's so hard to separate Cosby's work from his crimes, especially given that many of us manage to do so in other cases. One disturbingly plausible explanation, given American history, is that Cosby is less sympathetic than other artists who have committed crimes because he's a Black man who was successful in appealing to a white audience. People are likely to forgive those with whom they already have sympathy, and with whom they can identify, and white people are more likely to give old white men a pass for actions for which they'd want to see a Black man punished.

R. Kelly's case is likewise interesting on this point. R. Kelly is an R&B artist who has been accused of sexual misconduct with underage girls, sixteen-year-olds whom he filmed while they had sex. He is awaiting trial as of this writing on a federal charge of racketeering, which alleges that he had employees recruit women and girls to have sex with him. While his actions are wrong, he has been treated very differently from rock stars of the past. The predilections of stars like David Bowie tend to be treated as amusing anecdotes about the crazy days of '70s rock. Ann Powers writes that the beginnings of rock and roll are full of tales of rock stars pursuing teenaged girls, and notes that African-American artist Chuck Berry was

imprisoned following his conviction for transporting a minor across state lines for immoral purposes while white artists like Elvis Presley and Jerry Lee Lewis, who also had sexual affairs with teenagers, remained free.[7]

Racist institutions and policies mean that people of color are disproportionately likely to be the focus of criminal arrest, investigation, and conviction. The presence of epistemic injustice, as we learned in Chapter 3, means that white fans are less likely to be sympathetic to a Black artist who has done wrong than a white artist who has done the same. What comes to our attention and whips the media into a frenzy is surely affected by the same forces. It's worrisome to think that if Cosby had been a white comedian, he might be defended by the same people who denounce Cosby.

In both cases, however, there are reasons to think that more than racial animus lies behind the vitriol aimed at these artists. The movement successfully saw many of R. Kelly's performances canceled. The leaders of the #MuteRKelly movement, which saw many of R. Kelly's performances canceled, are Kenyette Barnes and Oronike Odeleye, two Black women activists, who channeled the feelings of many when they decided that "enough is beyond enough," and that R. Kelly's serial predation on young women of color should not be tolerated.[8] Cosby initially had some support from the artistic and charitable communities in which he was involved, but it seems to be dwindling following his conviction. While it's never wise to assume that race has nothing to do with public reception and reaction in 21st-century America, it seems here that racism can't be the entire explanation for why Cosby's crimes seem to be particularly repulsive.

Here's an alternative. Perhaps we've just confused Cosby and Huxtable. Recent research in cognitive science and

psychology tells us that despite what we may think, we are not always good at keeping fiction and reality separate. In one study, participants who listened to a fictional newscast were likely to wind up believing that some of the things that were reported in the newscast were true, even though they correctly reported that the newscast was fictional.[9] We are likely to believe that some of the things that we see on television dramas are true to life. In the early 2000s, some criminal prosecutors reported that they were having a harder time getting juries to convict defendants in cases similar to those that they normally won. After some investigation, they hypothesized that the jurors were subject to what became known as the CSI effect.[10] CSI was a popular serial television show in which every week heroic crime scene investigators would exonerate or condemn a suspect based on a seemingly trivial detail. Real-world juries were evaluating the prosecution's case based on what they believed about investigative procedures. While there is some debate as to whether the prosecutors' fears panned out, it's reasonable to think that we tend to conflate fiction and reality. How many of us think that we know something of medical diagnosis just because we watched the TV series *House* ("It's never lupus.")?

We are also likely to transfer our feelings about a character to the actor. Actors who play charming heroes are believed to be charming; actors who play creepy villains might worry correctly that they're going to be typecast. We know that the characters that the actors play aren't real, but we're nevertheless likely to transfer some of our beliefs about the character to beliefs about the actor.

Cognitive science explains that these phenomena occur because of the way the human mind processes fiction. Scientists believe that when we appreciate a fiction, our minds

run the same kinds of inferential processes that we use when we interact with the real world, as if we were pretending that the fiction was real. We imagine the characters as people, and draw inferences about what they'll do based on what we see, but also based on our knowledge of real-world human behavior. We'll flesh out the fiction beyond what we see and allow what we know about the real world to affect what we believe within the fiction. We know that the TV show *Friends* was fictional, but we might wonder, given what we believe about real-world New York City real estate prices, how a waitress and a cook ever afforded such a palatial apartment in Manhattan. We might expect to find the coffee shop *The Central Perk* were we to visit New York, even though we know that the character Rachel doesn't really exist. We expect that virtues like loyalty to friends are also virtues within the fiction.

The boundary between fiction and the real world is porous. We know intellectually that the situations and characters don't exist, and would respond that way if we were pressed, but to our minds and hearts what we see feels just as real. The phenomenon isn't necessarily bad. Fiction can be a powerful teacher and responding empathetically to imagined situations works like training wheels for our emotions. The result, however, is that it's much harder than we might expect to make a clean break between fiction and reality, and that has implications for how we think about the relationship between artists and their artworks.

When we watch *The Cosby Show*, we are invited to imagine Dr. Cliff Huxtable as an ideal dad. We can't engage fiction dispassionately. A character that makes us laugh is one for whom we are going to develop affectionate feelings; more so for a character that makes us laugh who is also a loving dad. Perhaps we find it hard to separate Cosby from his crimes

due simply to cognitive confusion. Cliff Huxtable, the lovable, respectable doctor in heavy gauge knit sweaters, is an admirable man, and so we mistakenly attribute those characteristics to Cosby himself.

Moreover, Cosby did much to encourage the connection between himself and the character. While The Cosby Show had a team of writers, the show was an extension of the generally family-centric comedy of Cosby. In commercials for Jell-O Pudding Pops, Cosby would appear as himself, not in character, but he would be wearing the sweaters that fans would readily associate with Huxtable. Cosby encouraged us to conflate his most famous character with himself.

As a result, it becomes hard for us to watch The Cosby Show without attributing the traits of Huxtable to Cosby himself. Once we recognize that we're making a common cognitive error, however, one might argue that we should simply stop doing that. Cosby is no more Cliff Huxtable than Robert Downey, Jr. is Iron Man. There is no shame in naively loving the actor because one loves the character, but we err if we don't subject our naive impulses to reflection correction. We should try not to confuse Cosby with Cliff Huxtable, and we should resist the temptation to idolize actors because of their characters.

If we could succeed in breaking the connection between Cosby and Huxtable, we might be able to preserve our enjoyment of The Cosby Show despite knowing about Cosby's crimes. Moreover, if projecting the traits of Cosby onto Huxtable is a kind of cognitive error, then we should attempt to break the connection between the two, treating Cosby's art like we do the art of Charles Dickens or Caravaggio. The work can be aesthetically and ethically valuable even though the artist is flawed.

If we are merely cognitively confused, we would not have much reason to avoid Cosby's comedy. We can separate his art from his actions and avoiding his comedy now will have no impact on him. His crimes came to light too late to derail his career. Watching low-fi clips of his comedy on YouTube won't endanger anyone. Listening to an album purchased in the mid-'80s won't line his wallet now. Aesthetic appreciation of his comedy will harm no one. Cosby's an old man who stands a reasonable chance of dying behind bars, and even if he walks free again, he will not be in a position to harm anyone further. Those in power reacted to his indictment. He's no longer on television, and the networks have pulled his shows from syndication. He has been removed from leadership positions of the foundations he helped create. Everything he built during his life has already crumbled under the weight of his crimes.

I think this argument is too quick. While there are good reasons to separate characters from the actors who play them, there is something unsatisfying about thinking that rejecting Cosby's work because of his crimes is due only to a cognitive mistake. Rather, I think the nature of comedy itself explains why Cosby's crimes are so hard to separate from his art.

III.

No doubt some of our anger with Cosby arises from the fact that we believed him to be like Huxtable in many morally significant respects, but I don't think we were wrong to do so. Cosby is a comedian, and while *The Cosby Show* employed writers who created much of the material on the show, the family-centric comedy presented in the show extended naturally from Cosby's stand-up acts, which often relayed stories of growing up, particularly memories of being parented. Huxtable was a fictional doctor, but he was the realization

of aspirations that Cosby himself held. The writer Ta-Nehisi Coates identifies Cosby's ideals as part of the "organic black conservative tradition,"[11] and Cosby championed a return to focusing on family, fatherhood, and self-reliance, a vision that eschewed waiting for white America to get its act together in favor of Black America returning to what he saw as the values of the 1960s. In his infamous "Pound Cake" speech before the NAACP in 2004, Cosby excoriated Black youth for failing to live up to their responsibilities, and Black parents for failing to instill values in their kids. The speech was controversial in the Black community. Some were sympathetic, but some saw Cosby as ignorant of the real challenges that face impoverished Black Americans. Sociologist Michael Eric Dyson writes,

> [T]he ink and applause Cosby has won [as a public speaker] rest largely on a faulty assumption: that he is the first black figure to stare down the "pathology" that plagues poor blacks … It is ironic that Cosby has finally answered the call to racial leadership forty years after it might have made a constructive difference. But it is downright tragic that he should use his perch to lob rhetorical bombs at the poor.[12]

Others saw his speech as a call to arms, an empowering message.

However, one interprets Cosby's speech, and whatever one thinks of his political activism, one can see the echoes of his views in *The Cosby Show*. One memorable sequence in the pilot features Cliff trying to impress upon his son Theo the importance of doing well in school.[13] Theo characteristically struggles in school, and explains that he'll just get a job like "regular people." Cliff pulls out the Monopoly money to

represent Theo's future salary. He takes money out for taxes, and then rent. Theo starts bargaining, economizing his future life. He'll live in New Jersey instead of Manhattan, and live on baloney and cereal, although he'll spend more on clothes. Cliff gets the last word – and the biggest laugh – by taking the rest of Theo's Monopoly money when Theo asserts that in this future life, he'll for sure have a girlfriend.

The sequence finishes, after an interlude, with Theo passionately explaining to Cliff that he doesn't need to be successful like Cliff and Claire, but that he should be loved and accepted anyway, because "I'm your son." Cliff waits for a beat; "Theo," he says softly, and then continues, his voice rising sternly, "that's the dumbest thing I've ever heard. No wonder you get Ds!" He sternly explains that Theo is going to apply himself, work hard in school, and that he is going to do so because "I am your father. I brought you into this world, and I can take you out of it."

That last line is a variation of a line the Cosby used in his stand-up routines about his own father ("I brought you into this world, I can take you out of it, and make another one that looks just like you!") Repeating the line reveals that Cosby is not merely playing a character, but that his personal comic sensibility infuses the show. Cosby retained considerable creative control over the show, including small details like the inclusion of historically Black colleges and universities whenever the characters talked about college ambitions.[14] It's not a mistake to see Cliff Huxtable as the extension of the comedic persona Cosby honed over the years.

If we are to treat Cosby's comedy as art, we need to think about how comedy works. One family of philosophical theories explains laughter as the natural response to incongruities. We move from the world with certain expectations of

what is supposed to happen, and when we discover that con-
crete reality does not match our abstract conception of the
world, we laugh. A friend who is a philosopher likes to tell
the story of his son's first joke, performed at six months old.
The baby was being spoonfed some nourishing puree when
he decided to bite down on the spoon so that it couldn't be
removed, and then giggled at his parents' frustration. The
baby understood intuitively what Schopenhauer had ana-
lyzed more than a century ago: the joke is the intention-
ally ludicrous, the result of an intentional attempt to bring
about a discrepancy between reality as we perceive it and
our concepts. The baby bites down on the spoon and then
laughs because he's thwarted what's supposed to happen.
The incongruity is funny.

Alert readers will note that not all incongruities are funny,
and not everything that is funny results from an incongruity,
but they will also notice that plenty of comedy works by set-
ting up expectations only to undermine them. The Monopoly
lesson from the pilot features two incongruities. The first lies
in the trope of the father advising the son, only to be under-
mined by the son deciding to bargain about the advice. The
second lies in the inversion of the typical '80s sitcom dynam-
ics. The studio audience coos after Theo's heartfelt speech,
signaling that they're expecting the typical sitcom resolution
to the conflict of the plot. Cliff will grudgingly, but lovingly,
give into his son's wish to be like "regular people," accept his
Ds in school, and stop pushing him to succeed academically.

When instead, Cliff turns into a stern father, we laugh. We
laugh at the joke, but we also laugh at the studio audience,
who had been approvingly cooing at the expected resolution
the moment before. The artistry of this sequence is evident.
It's all too easy to imagine versions of this scene, that without

perfect timing or intonation, sound abusive instead of funny. It's clear, in the pilot and the rest of the series, that while Cliff is unyielding he is never cruel.

To master this balance requires insight into human nature, parenting, and the norms of comedy. Over and over in *The Cosby Show*, certain abstract concepts like *parenthood* and *a good marriage* are explained through jokes, usually through the failings of some of the characters to live up to the ideal. If a joke is an intentional attempt to fabricate an incongruous situation by contrasting an abstract idea with a concrete example, a *good* joke presupposes a thorough understanding of the concepts involved. To joke about the family requires that the *comedian* understands the family.

We need not be naive. While such comedy requires the *appearance* of authenticity, we need not conflate the comedian with their persona. We need, however, to be able to feel the authenticity of the comedy when we watch their comedy. A comedian whose routine feels like the recycled material of others will not be funny.

It's reasonable to assume that for Cliff to joke as he did, Cosby himself must have understood what he joked about; his later activism, his call-out performances belie what we already had reason to believe. Moreover, much of Cosby's comedy is first-person storytelling, seemingly about the comedian as a person, not as a mere persona. Stand-up requires the appearance of authenticity. The comedian develops their own material, and usually talks in the first person: things they noticed, things that happened to them, *their* observations.

Successful comedy of this kind requires trust, trust that even while we know that the events the comedian describes are fictionalized, their point of view is their own. As a result, it's reasonable to think that the antics of Cliff, in combination

with Cosby's stand-up comedy and books, revealed something authentic about Cosby's way of seeing the world. It's not a mere cognitive error to think that the lessons imparted by the Cosby show were understood by Cosby himself. If Cosby saw the world authentically as one in which good fathers guided their sons morally, and he had a sufficiently sophisticated understanding to be able to showcase the difference between tough love and overly authoritarian parenting, then we're not unreasonable when we think of Cliff as a genuine role model for parenting. To enjoy his comedy is to be invited to share that vision, to regard Cosby as someone who understood the concepts about which he joked.

The word that comes to mind when I think about Cosby's crimes is *betrayal*. The betrayal is aesthetic because his comedy relied on the authenticity of his insights. His comedy requires Cosby to be the man that he told us he was. His criminal conviction tells us otherwise. We're not making a cognitive mistake when we attribute some of Cliff's characteristics to Cosby. Even if Cosby hadn't played up the connection with the pudding pops and the call-out speeches, his style of comedy requires the audience to believe that his persona is authentic. Had he merely been an actor hired to play a comedic role, we could maintain the distinction between the character and the man. We could tell ourselves that actors just mouth the words others write and that we should no more expect Cosby to be like Cliff than we should expect an actor who portrays Superman to fly.

Cosby's comedy, however, requires us to be able to believe in the persona that he put forward. With the revelations, we can't help but wonder whether it was all just an act. Was his persona cover, so that no one would suspect him? Were his charitable efforts a distraction, or attempts at penance? Was he laughing at us all along?

The Cosby case hints at the importance of aesthetic authenticity, the sense we have that the artist is producing art because they find doing so to have aesthetic value. Anything that undermines that sense of authenticity feels like a violation of what the philosopher Thi Nguyen calls "aesthetic trust," the trust we reflexively place in artists, the expectation we have that their artwork proceeds from a place of genuine aesthetic sensibility.[15] I am not a great fan of Woody Allen's movies, but it's hard not to notice how often the stories of his films star him and some startlingly beautiful young ingenue who inexplicably finds him attractive. For the fans, this recurring trope is a mark of authenticity, a genuine depiction of what it feels like to be a neurotic middle-aged man in contemporary America, with perhaps a side of wish fulfillment. When it was revealed that Allen was involved in an affair with the daughter of his former lover, for me his works almost took an apologetic character, as if they'd been presented in partial defense of his own behavior. Enjoying a film feels like endorsing his worldview. His misconduct forces us to re-evaluate his artistic choices. We start to wonder if the plots of his movies were nothing more than attempts to normalize his questionable behavior. By contrast, while allegations that he molested his daughter, Dylan Farrow, if true, are evidence of his moral monstrosity, they do not by themselves seem to violate aesthetic trust.

Louis C.K.'s sexual misconduct also seems to force us to re-evaluate his art. Much of Louis C.K.'s comedy featured him doing things a little bit off-kilter, including a sequence in the canceled I Love You, Daddy where he masturbates while peering at a beautiful coworker unawares. When it was revealed that Louis C.K. had repeatedly masturbated in front of female colleagues, bizarrely asking them for permission without apparently realizing that his position as a powerful gatekeeper made

it nearly impossible for them to refuse, his comedy seems different. Now it's not just an off-kilter weirdo making observations about life; it's a guy seemingly justifying masturbating in front of others and using our approval of his comedy to do so.

The misdeeds of these three comedians vary in severity, but they share in common that their actions make it hard to see their work as aesthetically authentic. Good art is supposed to be, to borrow Kant's phrase, *disinterested*, presuming a kind of impartiality where what is presented is offered to us only because it is aesthetically valuable, without any kind of ulterior motive. It requires the artist to be authentic, not in that they are perfect, or that their work comes only out of lived experiences, but that what they present to us grows out of their unique sense of what is aesthetically valuable.

Authenticity in art is hard to define, but we know what it's like when we experience it or fail to find it when it's lacking. In contexts outside of art, we might speak of living authentically as synonymous with doing only what one determines to have value, rather than unreflectively adopting what others value. When applied to art, authenticity tracks aesthetic value. Consider a band that is believed by its early fans to have *sold out*. On the surface, calling someone a sell-out might seem like an odd criticism. What could be better for a band than for their music to be heard by everyone? What's wrong with other people *liking* the band's music more? It doesn't seem wrong for a band's music to reach more people, or for them to like it when they hear it. Making money because one is unusually good at something isn't typically thought to be wrong in a capitalist culture.

To be a sell-out, however, is to have compromised one's artistic integrity in order to chase money. A sell-out isn't

performing music or painting out of an authentic desire to create art and share it with the world. They're trying to make money, and odds are good that they're changing their unique style to do so. Commercial success often neatly lines up with aesthetic mediocrity. Simple economics makes mediocrity the most likely result. If one wants to make a blockbuster action movie, one must cater to the tastes of the broadest subset of young men who make up the audience, and one doesn't do that by presenting a challenging aesthetic vision. There's a formula for churning out such movies, and one suspects that Marvel's twenty-three (and counting) nearly identical superhero movies have cracked it. The opposite of the authentic is the formulaic; paintings shouldn't be paint-by-numbers.

Being authentic isn't sufficient to bring about good art. A folk singer could be authentic yet awful. Nor is authenticity essential to all art. Pop music arguably doesn't concern itself much with authenticity at all. For some art forms, however, authenticity forms the backbone of aesthetic appreciation. And this is true of comedy. In cases where an artist's misconduct gives us reason to suspect that their work can't be genuine, then what was a mere ethical flaw in them becomes an aesthetic flaw of the work. In the case of Cosby, when we try to separate the comedy from the comedian, we find there's nothing left of the joke.

IV.

We cannot separate the art from the artist when the wall between the artist's personal flaws and their artwork is breached, and in such cases, the misdeeds of the artist force us to re-evaluate the artwork. I can't enjoy Cosby's work as I did twenty years ago. I can't make myself overlook Cosby's crimes, and there's no reason that I should try. The decision to

stop enjoying an artist needs no reason, but Cosby's behavior has given plenty.

The preceding discussion's aims have been *descriptive*, an attempt to understand the aesthetic and psychological mechanisms by which the artist's behavior informs our interpretation of his work. We have not yet considered whether we *ought* to let the artist's ethical failings inform our engagement with their work. Suppose that you learn of Cosby's crimes, and you believe sincerely that he's done wrong. Moreover, you understand that there's a case for thinking that the body of his artistic work has been sullied by his work. You don't disagree with the argument, but you find yourself simply not moved by it, because you judge that, overall, his work is aesthetically valuable. You're very good at compartmentalizing, and don't experience Cosby's crimes as rendering the work fatally flawed.

Do you have an obligation to try to change yourself into the kind of person who regards ethical flaws as aesthetic flaws? One might reasonably think that truly being ethical requires not merely doing the right things, but having the right attitude toward injustice. A saying attributed to Confucius reports that true virtue is not merely a matter of ensuring that one acts correctly, but "the expression on the face is the hardest." With hard work, one can become the kind of person who doesn't merely do the right thing as if they were a robot, but the sort of person who takes joy in virtue and disdains vicious behavior. Cosby's behavior should alarm us and stoke righteous indignation. Reacting as if nothing has changed might strike as us as pointing to ethical immaturity on our part. We might worry that our sense of ethics is hollow if we can easily detach an artist from their artwork, especially in cases where others seem to be profoundly moved against us.

In some circumstances, that worry seems to be well-placed. Fiction in particular demands certain emotional responses of us, and to be improperly moved could well indicate a flawed character. Someone who isn't concerned at all that *Triumph of the Will* praises Hitler is not properly allowing their evaluation of Hitler's crimes to influence their responses to his artwork. When the content of the work itself recommends a particular emotion – sadness, joy – one might pause if one finds that one does not respond at all. A lack of emotional feeling toward art could suggest a worrying lack of empathy. A genuine failure of empathy toward other human beings is a character flaw, and ethics would require those who suffer from such a flaw to take steps to address it, but the ethical requirement is to become empathetic in the right way; the response to art is secondary.

Most of the time, however, our aesthetic preferences aren't diagnostic of anything at all. What moves us aesthetically, and the strength by which it moves us, is personal, and outside of extreme outliers it's hard to see that it's a good use of our time to change it. Moreover, sometimes our aesthetic reaction to works results from the different weighting of ethical and aesthetic values. The philosophers who defend ethicism are clear that a work can be ethically flawed yet on balance aesthetically successful if its aesthetic merits outweigh them. Someone who agrees that Cosby's crimes are monstrous, but who finds his work valuable enough that they can compartmentalize it, disagrees with me about that weighting. But they do not seem to be guilty of an *ethical* error. Responding or failing to respond to an artwork is not straightforwardly an ethical matter, and it doesn't look as if there's a case for thinking that we would have an ethical obligation to try to reform

ourselves so that we're disgusted by artists. There seem to be many better uses of our time and energy.

Nevertheless, we can use the occasion for self-reflection and self-improvement. If you find yourself unmoved at all by #metoo allegations and reports, it's worth thinking why. We also should remind ourselves to resist the temptation to idolize artists. Art makes life wonderful, and we would be worse off in a dull practical world with no songs or movies or paintings. Being an incredible creator of art, however, should not make one immune to suspicion. Being a great artist, or a great sports star for that matter, does not make one a moral role model, and we should take care to remind ourselves of that. We should never excuse misconduct, and we must beware of the tendency to minimize misconduct just because we like someone's artwork.

Rumors of Cosby's misconduct had been swirling for years before the accusation led to his arrest. Imagine what would have happened if we'd managed to resist the tendency to conflate Cliff Huxtable with Bill Cosby. He wouldn't have been America's Dad any more than he was Superman. His accusers might have been emboldened, more willing to come forward. We might have given them a fairer hearing. Perhaps we collectively would have done better by his victims. But if we're looking for a reason to boycott Cosby's work now or the work of other immoral artists, we still don't have one.

Five

I.

At the Golden Globes in January of 2016, the actor and comedian Aziz Ansari won a Golden Globe for Best Actor for his work on *Master of None*.[1] Ansari portrayed Dev, a Muslim-American actor trying to advance his career and figure out dating, and the comedic themes of the show, which Ansari created, mirror the themes in Ansari's stand-up routines, which mostly are about dating and the changes in dating culture wrought by technology. His work is not only funny but insightful, so much so that he collaborated with sociologist Eric Klinenberg to produce a book, *Modern Romance*, about the ways technology like texting, Tinder, and social media affect how young people navigate dating and relationships.[2] Ansari's comic work relies not only on his relatable perception of dating life but also on his focus on the underlying unspoken ethical norms that underlie online interactions. He also presents himself as a feminist, and generally as a good guy who genuinely wants to avoid harming others. At the Golden Globes, Ansari wore all black, in support of the #metoo movement and of the coming reckoning that many in entertainment felt was long overdue.

One week later, Ansari found himself accused of sexual misconduct. The online magazine *babe* published a pseudonymous tale from "Grace," who recounted a date she had with Ansari the previous fall. According to Grace, after retreating to

Ansari's hotel room, he became unexpectedly sexually aggressive, pressuring her into sexual acts that she did not want to do. Unlike most of the cases in the #metoo movement, Ansari was not her employer or co-worker. The tale was one of a date that left her very upset and wondering if her experience was sexual assault. A man who she believed based on his persona would be a gentleman turned out to be somewhat less than that.[3]

The piece immediately went viral, and nearly as quickly came the hot takes. Opinions differed. Some thought it was nothing more than a hit piece, "revenge porn" by a woman who had been expecting a romantic date with a famous man and was startled to find that a famous man might be sexually aggressive around a naked woman.[4] Some saw Grace's story as an indictment of modern dating culture, where men badger women as if they have to wear down their resistance to sex.[5] One article criticized the *babe* piece as just about "a date that went badly," not "sexual assault or anything close to it by most legal or common-sense standards."[6] For his part, Ansari said that the encounter occurred, that had he believed everything was consensual, and that he was surprised and shocked to learn that Grace hadn't felt the same way.[7]

Grace told her story to *babe* after Ansari's triumphant televised night at the Golden Globes. Six months after the date, there was no realistic hope of criminal prosecution. Instead, what Grace wanted to do was call out Ansari for his behavior, and the long coattails of the #metoo movement provided a convenient way to do that. Ansari wound up *canceled*.

CANCELING

To cancel an artist is to deny them social recognition, attention, and money by announcing that one is ignoring them,

and then presumably following through by not engaging with their artwork. To be canceled, the person must usually be part of the attention economy, where someone's livelihood depends significantly on getting other people to pay attention to them.[8] One can cancel a celebrity who depends on Instagram followers for endorsements and ad revenue, or an artist with a public social media presence, or a writer who writes for a web magazine.

Cancellation, and the culture surrounding it (termed "cancel culture," but I'm not going to use that term because it's become overly politicized), has its roots in the call-out. To call someone out is to shame them for violating the standards of a shared group. Loretta Ross, a scholar of women's issues, racism, and human rights, recognizes cancellation as arising from the same impulses that led her as a young Black feminist activist in the 1970s to criticize other activists.[9] In that sense, cancellation is nothing new. It's also not the first time that communities have gathered to reject the work of artists. Some readers may recall that when John Lennon exclaimed that the Beatles were more popular than Jesus Christ, church groups in the U.S. responded by hosting burnings of Beatles albums. The religious groups were communicating that Lennon's words were unacceptable to them by demonstrating that they were going to refuse to listen to their records, and presumably would buy no more Beatles albums.

The difference between canceling and a Beatles boycott, however, lies in how canceling typically works. Canceling requires social media, and social media facilitates connections between people who might otherwise never have met each other but who share experiences in common. They are part of an *imagined community*, a socially constructed community whose members belong to it not because of physical proximity or

blood relations but because of similar interests and the ability to communicate.[10] Social media facilitates the creation of novel imagined communities focused on many kinds of interests such as college sports, manga, and Crossfit. These communities are easy to join, with no barriers to entry beyond smartphone or Internet access. Members then use the social media platform to communicate, and they need to know nothing more about each other; even anonymity is acceptable.

There is an imagined community that corresponds to the set of social concerns that gave rise to the #metoo movement. Anyone can join in; the imagined community of the socially concerned Internet applies to anyone who chooses to follow or use a hashtag. Individuals who want to attempt to garner support for a cancellation can build on the work done by others, using hashtags for publicity. They don't need to have been already part of the community to participate in cancellation; they can just follow whatever is trending.

The ethical case made in favor of cancellation is simple. No artist is owed our attention, and even the slimmest of aesthetic reasons is normally enough to justify not engaging with an artist's work. If aesthetic reasons provide sufficient grounds for not engaging with an artist's work, surely a good ethical reason will also provide sufficient grounds. To put it another way, if it's acceptable for someone to refrain from engaging with Michael Jackson's music because they simply don't care for pop music, it has to be acceptable to do so because they do not want to support someone who they believe molested children.

We should consider, however, whether there are ethical concerns with cancellation. One might have thought that cancellation is simply deciding based on the artist's behavior that one no longer wants to listen to them. As we usually have

wide latitude when we think about what kinds of art we want to consume, we might be tempted to think that there are no ethical concerns about cancellation. If "it's not to my taste" is a good enough reason not to listen to a musician or watch an actor, it's hard to see how having a more thoughtful reason could make the decision less ethical.

On the surface, this seems plausible. A lot of the appeal of cancellation is that it's simply giving us a new set of reasons to consider when we decide which artworks to consume and insisting that the ethical behavior of the artists is a relevant criterion. Given what we've said so far, we might reasonably think that the ethical behavior of the artist doesn't *require* any particular response from us. But we might also think that any kind of reason would be fair game, and that if someone wants to live their aesthetic life in such a way that the behavior of an artist is a primary reason for them not to engage with the work of that artist, then there's no conceivable ethical problem. Having a more thoughtful reason to refrain from engaging with an artwork can't all by itself constitute an ethical breach.

Nevertheless, there are certain kinds of reasons that are ethically suspect. Refraining from watching *Master of None* because one harbors racist prejudices against Indian Americans, for example, is unethical because one shouldn't harbor racist prejudices. If someone decides not to engage artwork an artwork out of racism, they'd be doing so under the influence of a bad reason. Thus, it's not the case that *all* potential reasons that lie behind our aesthetic consumption choices are fine. Ethics still applies; it's just that most of the time, our reasons sit in the class of innocuous matters of taste that are up to us.

You might think cancellation is in the clear. Most people thinking about canceling an artist have morally praiseworthy

reasons for doing so. They're motivated genuinely to do what they can to disdain those who commit sexual assault and sexual harassment. Nevertheless, I think there are some reasons to think that participating in cancellation can be ethically troublesome.

Let me pause here to note that the ongoing conversation about the ethical dimensions of cancellation is heated, as one might describe an active volcano. On one side, critics of cancellation argue that its presence undermines freedom of speech and the proverbial marketplace of ideas, because writers and other creatives fear that if they say what they believe, they'll be the target of a social media mob that aims to take away their livelihood. Others fire back, arguing that at most what they fear is not being able to say what they want without any consequences. The debate spills over into other freedom of speech issues such as how colleges decide who gets to speak on campus and or whether there are bounds on what topics or approaches are acceptable, and how academic journals should deal with sensitive topics. Then there's the meta-debate: is cancellation worth worrying about compared to other threats to free speech? What distinguishes cancellation from a community setting boundaries of polite discussion? Isn't it just so tiring to have to continue to have this discussion? Add to this the intense political polarization of the early 21st century and wading into this debate might strike you as about as appealing as diving into said active volcano.

So it's worth being very clear about my intentions. While I think that cancellation is worth extra ethical scrutiny, I also think that, most of the time, it's only a *moderately* big deal. An unfair cancellation is not the greatest threat to freedom of speech today, but neither is it negligible, and it's worth thinking through its implications.

The problem with cancellation isn't the reasoning; it is good to be against sexual assault and harassment, and fine to decide not to engage with the art of immoral artists. The problem is the mechanism of cancellation. Social media structurally rewards shallow thinking and swift interaction. There's no room for nuance, and no time to waste if one wants to participate. The result is that cancellation is often unfair to its target and participating in cancellation makes us worse at thinking about ethics. Even if we rightly care very much about the injustices of sexual assault and sexual harassment, we should be cautious about joining in on calls to cancel celebrities.

II.

Many of the discussions of cancellation in the popular press treat it as the sentence laid down by the court of public opinion. Someone screwed up; we judged them for it and canceled them, and, if they properly make amends, then they can be restored to our good graces. People worry that "the punishment doesn't fit the crime." We may as well start by taking the legal analogy a little too seriously.

There are three reasons that we might suspect that cancellation is a poor substitute for genuine justice. First, cancellation is insensible to the severity of whatever the celebrity has done. Second, cancellation is arbitrary, as whether someone's wrongdoing results in cancellation depends mostly on the whims of the Internet's attention. Finally, cancellation is an indefinite punishment; there is not yet a recognized way for a canceled artist to make amends. Cancellation isn't part of the legal system, but if it were, we'd recognize it immediately as flawed.

As a species of shunning, cancellation inherits some of its limitations. Shunning prescribes one kind of punishment – exclusion from the community – for all wrongdoing.

Cancellation likewise prescribes one kind of punishment – denying money and attention – regardless of the severity of the actions that led to the call for cancellation. There have been calls to cancel Michael Jackson, Harvey Weinstein, Bill Cosby, Aziz Ansari, Louis C.K., and R. Kelly, among others, in response to alleged (and convicted) sexual misconduct. There have also been calls to cancel Dave Chapelle, Shane Gillis, James Gunn, and Taylor Swift, among others, for offenses ranging from crude transphobic comedy and racist jokes to bad tweets and feuding with Kim Kardashian.[11] Figuring out the correct relationship between punishment and crime is a subject for a much different book than this one, but it shouldn't take too much of a sense of proportion to recognize that sending an obscene tweet isn't the same thing as assaulting women repeatedly over decades. It should be obvious that these behaviors are not of the same severity. Yet canceling prescribes the same punishment in all cases. It is insensible to the kind of crime or the amount of harm done.

That doesn't leave room for much nuance. As cancellation has become more popular, it's spread to borderline cases and beyond the #metoo movement. In 2018, director James Gunn was fired for making what he called "totally failed and unfortunate efforts to be provocative" on Twitter.[12] James Gunn's tweets were a *decade* old, dug up by conspiracy theorist Mike Cernovich, likely in revenge for Gunn's criticism of President Donald Trump.[13] In Internet terms, a decade ago might as well have been the Mesozoic; one might be surprised that Cernovich found the tweets without the aid of paleontologists. Gunn had successfully directed the blockbuster hits *Guardians of the Galaxy* (*Vols.* 1 and 2), but his inappropriate tweets, joking about pedophilia, did not please Disney, a studio known for its family-friendly image.

When Disney fired Gunn over the tweets, many thought that his firing was unfair.[14] It is rare for someone to want to be judged by the standards to which they held themselves on the Internet a decade ago. No one started out offended by Gunn's tweets. The tweets had dropped over ten years ago and mostly been ignored. No one believed Gunn was a pedophile. No one thought that his tweets made him a less able leader, or a risk to the actors on the set. Instead, Gunn's politics offended people who then went through his public history with an eye to finding something to get him in trouble.

Eventually, Disney recanted. Gunn has been rehired. He did apologize, but one can't help but cynically suspect that they fired him just to stop bad publicity, and that they weren't concerned about the content or his behavior in the future. What this suggests is that one of the highest-profile cases of cancellation didn't need to happen in order to protect anyone. The madding crowd wanted a scalp, and a scalp it got, if only for a short while.

Ansari's case also struck those who believed him to be guilty only of being a bad date as overkill. Without the #metoo movement, Grace's story wouldn't have had any traction. While he may have behaved boorishly, he didn't (unlike, say, Weinstein) prevent her from leaving when she made it clear she wanted to go. He didn't create a hostile work environment for Grace because they weren't co-workers. The point here isn't that Ansari and Gunn were unfairly treated, or that they shouldn't have lost their jobs over their behavior. There's room for disagreement here. It's that cancellation seemingly erases the difference between a crude tweet and serial sexual assault. There's one punishment for all offenses. Proportionality is a longstanding and important part of justice. Worse crimes should be met with harsher punishments. A system where

shoplifting is treated the same as murder is either treating murder too lightly or shoplifting far too seriously.

The second reason one might think that cancellation is a poor substitute for justice is that it's arbitrary. Similar cases should be treated similarly under the law. If cancellation is a matter of meting out punishment to those who are outside the reach of the legal system, then cancellation mustn't be arbitrary. Unfortunately, it is. First, there's a significant element of chance regarding what gets attention and what doesn't. As we saw in Chapter 2, what captures the Internet's attention does not reliably track the severity of the problem. As I write this paragraph, the COVID-19 pandemic is sweeping the world, and the #metoo movement is completely out of the headlines. Nothing is going to go viral now that isn't a) a virus or b) *about* an actual virus, except maybe Animal Crossing or recipes for sourdough. That doesn't mean that sexual harassment isn't happening, or isn't serious, just that the Internet's attention span is preoccupied right now. If you're calling for justice, please hang up and leave a message.

Second, some people are too big to cancel. Michael Jackson is accused of molesting children, and the accusations have been the subject of a hit documentary. His crimes rank among the worst in the informal hierarchy of evil, and they've been publicized as widely as they possibly could be. Nevertheless, Jackson hasn't been canceled, and odds are good he never will be. His influence is too lasting; his music, too infectious; and the accusations, too late in his career. The fact that some people can't be canceled no matter the enormity of their crimes makes it seem even more arbitrary. An Internet mob is going to be mostly powerless against powerful, wealthy people, but the same call for #justice could destroy the life of someone less powerful, even if their so-called crime was far less significant.

Finally, one might think that cancellation is fundamentally unjust because the person who is canceled does not have an obvious way to come back from it. Most theories of punishment make some provision for the restoration of the person who has done wrong to the good graces of society. A person who commits a crime and serves their time can return to their life, including returning to work.

For example, if a truck driver is caught in the state of Utah operating a vehicle while under the influence of drugs or alcohol, he will immediately lose his commercial driver's license for a full year. If, however, the driver completes court-ordered treatment and stays clean, in a year, he can reapply for his license. A first offense carries a significant penalty due to the hazard to public safety, but society has provided a way for the person to recover their livelihood. As a society, we want a path back for people who have done wrong, if for no other reason so that people who have committed a crime have options besides doubling down on a life of crime. A just system of punishment provides a way to restore the person's standing after they've made amends.

There isn't a script for coming back from cancellation. Many artists cannot be canceled; the hashtag is willing, but Internet outrage is weak. There's also no consensus on how long someone must be canceled before they're allowed to come back. In some cases, such as Weinstein's, being canceled is secondary to the machinations of the legal system. Weinstein's been convicted of sexual assault and must serve his legally mandated prison term. He's not going to be producing films until after he serves his sentence, if ever. Most cases of cancellation, however, don't run in parallel with a criminal conviction. Rather, they stand alone as attempts to derail someone's career in lieu of any formal

conviction and punishment. If cancellation succeeds, the canceled artist might not work an artist again.

This makes cancellation a little weird. On the one hand, we don't generally recognize a right to *have* any particular career. If I want to become an astronaut but discover that I have neither the mathematical aptitude nor the physical prowess required to handle the rigors of space, no rights of mine have been violated.

One can't decide to be a comedian, fail to get any laughs, and claim to have a right to be on the stage. Even being good isn't a guarantee of an audience, as audience tastes are fickle. Katherine Hepburn, one of the greatest and most successful actresses of her generation, was described for a while as box-office poison. Artists arguably have the right to try to make careers as artists, but they do not have a right to public acclaim. If the public doesn't want to enjoy their art because of their bad behavior, it's hard to see how they've been wronged.

On the other hand, there does seem to be something strange about the end goal of cancellation. It's as if we've mentally sorted careers into categories, and some careers are simply not permissible for anyone guilty of sexual misconduct. If Aziz Ansari had been a truck driver instead of a famous comedian whose act incorporated feminist themes, probably *babe* magazine wouldn't have cared and he wouldn't have lost his trucking job. Even if he had, somehow, it seems implausible that we'd think that what he did forever ruled out being a truck driver, accountant, or investment banker.

Nevertheless, the fact that there's no provision for how an artist can be restored to the public's good graces means that it's hard to find a path forward. Artists seem to default to the timeworn PR strategy: spend some time out of the public eye, appear contrite, and attempt a comeback. Comedian Louis C.K.

tried this strategy at The Comedy Cellar. He didn't announce his comeback in advance; The Comedy Cellar schedules acts but also regularly features famous performers who drop in to do a set unannounced. While the immediate audience received it well, others weren't ready to forgive him. Roxane Gay summed up the sentiments of many when she wrote, "I have to believe there is a path to redemption for people who have done wrong, but nine months of self-imposed exile in financial comfort is not a point along that path."[15] She suggested that he should pay for at least as long as those whom he had harmed suffered, financially compensate his victims, and publicly admit what he did and apologize sincerely. Amanda Hess also points out that when a wrongdoer returns to fame, the inevitable result is that the victims are trotted out again because the media wants their perspective on the story.[16] His return harms them.

It would be great if Louis C.K. followed Gay's advice: making amends would undo much of the damage he has done. Canceling him, however, won't force him to make amends. Hess observes that "we like to think a person can be canceled because of low moral character" but acknowledges that if the person doesn't agree to stay out of the limelight, they won't be. The trouble is that C.K.'s simply too good at what he does for the majority of fans to care. He's keeping a lower profile than he used to, and estimates are that he lost nearly USD $35 million during his ten months in self-imposed exile, but he has returned to touring, and while the venues are smaller than they used to be, he's still achieving a remarkable level of success that most comics would hardly dare to dream of. Moreover, he's done so by doubling down on the more abrasive and shocking aspects of his comedy, appealing to an audience that is "exhausted with public shaming."[17]

The logic of cancellation presumed that there were only two outcomes of any attempt to cancel an artist. Either the artist would make appropriate amends and return to public life and fame or they wouldn't and would slither away somewhere to go get a job flipping burgers. Thus, most of the discussion of the ethics of cancellation has focused on evaluating those two outcomes. Is it fair that someone can't work in their chosen career? Is someone coming back too soon or without proper contrition? The problem is rather that there is a neglected alternative, illustrated by Louis C.K.'s new tour. It's a big market. Someone with Louis C.K.'s comedic talent can shift his focus and bring in a new audience, perhaps full of people tired of the #metoo movement, who simply don't care about his victims, or find him funny enough that they overlook it.

To put it another way, if taking away fame is supposed to be the punishment, cancellation perversely incentivizes getting fame in another way. Writers and academics who have been canceled due to unpopular views or politics sometimes find a new social network full of other cancellees. There are new platforms such as the online magazine *Quillette*, whose editor Jonathan Kay describes himself as "an ambulance chaser for the canceled."[18] In an increasingly polarized culture and a low bar to media access, there's an audience for everyone. Rather than encouraging someone to make amends to be restored to the community, cancellation drives them further away to find new sources of fame and attention.

These three features of cancellation make it likely that any given instance of cancellation will be a poor substitute for justice. It might be a disproportionate response to an offense, or arbitrary in that it came to our notice only because of a slow day in the news cycle, and the canceled artist might have

no clear path back to make amends, and they might decide to double down, especially if their offense was ideological or political. That said, participating in a cancellation risks contributing only in a small way to making the world a little bit worse. It's wrong, but probably not worth the think pieces decrying it.[19]

Yet participating in cancellation risks violating another, more serious, ethical obligation. We run the risk of engaging in moral grandstanding, posturing so that other people think we are on the right side of morally important issues without contributing much of substance to them. If participating in canceling contributes to moral grandstanding and we have an obligation not to grandstand, then we should not participate in canceling.

III.

Social media not only provides the space for imagined communities to gather but has several features that not only make cancellation possible but shape how it happens. Social media platforms like Twitter, Tumblr, Instagram, and Facebook allow users to share content that was originally posted by other users. If you really like this book, you can tweet about it or post about it on Facebook or take a selfie to post to Instagram, and then your followers can choose to "retweet" or share your post with their network. If enough people like your content and send it to others, then you will go viral (and maybe I'll earn some royalties!).

Most platforms also allow users to interact with posted content to express their approval: one can "like" or "react" to posts on Facebook, or "heart" tweets and Instagram posts. The number of reactions and hearts is posted publicly, and so are the shares and retweets, so it's easy to see at a glance

whether what one has posted is popular. Many platforms also limit or encourage the length of posts; the platforms are not places for long discussions. Twitter caps tweets, for example, at 140 characters for non-verified accounts, and even though one may link to longer pieces, most links are never clicked.[20] Some social media platforms also use the hashtag, "#," which is placed in front of a word or phrase. Users of the platforms can search hashtags and see which ones are "trending" or tagged onto content by many users. A fan can't cancel an artist by themselves; they need others to join in, and so their call on social media must go viral.[21] Not just anything will go viral, however; that which gets retweeted depends on its use of language, how catchy and headline-like its slogan is, and whether it uses words that other people have used.[22,23]

The combination of the constraints of social media and the need for virality lead to an interesting moral problem for canceling, and one that curiously has almost nothing to do with the behavior of the morally compromised artists. Social media is a great environment for moral grandstanding, and cancellation in many cases is just a narrowly focused kind of moral grandstanding. Philosophers Justin Tosi and Brandon Warmke define moral grandstanding as making "a contribution to public discourse that aims to convince others that one is 'morally respectable,'"[24] as opposed to a contribution that genuinely aims to add moral reasons to public discourse. Grandstanding is morally wrong; as they quip, "to grandstand is to turn one's contribution to public discourse into a vanity project."

Grandstanding is characterized by caring primarily that one is seen as a morally respectable person by others with respect to some area of moral concern. The politician who grandstands in front of the factory may or may not genuinely

care about the plight of the workers assembled to hear his speech, but you can be certain that he cares whether he *looks* like someone who genuinely cares.[25] Grandstanding is public; someone who grandstands writes or says something to get other people to believe that they are morally respectable. Politicians can't grandstand without an audience.

Tosi and Warmke identify five characteristics of grandstanding behavior: piling on, ramping up, trumping up, excessively emotional rhetoric, and claims of self-evidence. An act of grandstanding piles on when it repeats something that's already been said to demonstrate that one is on the right side.[26] Something that's already been said doesn't need to be *added* to public discourse, so the reason for piling on is to mark one's status as socially respectable. Grandstanding ramps up when grandstanders try to outcompete each other by making ever stronger claims and trumps up as grandstanders insist there is a moral problem when there is none.[27] Someone who ramps up does so to show that they are even more morally respectable than everyone they're talking to, and someone who trumps up a problem does so to show that they're so morally respectable they notice even the tiniest hint of injustice. Grandstanders also often display excessive outrage, as "the implicit assumption is that the most outraged person has the greatest moral insight or perhaps the strongest moral conviction" about whatever is being discussed.[28] And finally, grandstanders tend to claim that their position is so obvious as to be self-evident, refusing to engage others any further, usually claiming that anyone who can't see their point is lacking some key elements of moral sense.[29]

It's easy to see why participating in cancellation so often is no more than a form of grandstanding. Imagine that you decide to cancel Michael Jackson. First, you're not going to

cancel him by simply refusing to listen to his songs. To cancel, you must publicize that you're refusing to listen to him anymore. Moreover, you're not going to publicize it just by talking to your close circle of family and friends. You're going to publicize it by putting it on Twitter so that everyone can see that you are on the right side of this moral question. You're just warming up, though. You're not going to be content to publish it to the entire world, but you're going to make sure you use the hashtag #NoMoreMichael, so anyone interested in it can see that you yourself are morally respectable. You're going to try to be funny and memorable so that later people will heart and retweet it.

(Maybe you'll even go viral.)

Every single characteristic that Tosi and Warmke identify as characteristic of grandstanding is actively promoted by the structure of social media. Retweets *pile on*; retweets with sanctimonious commentary *ramp up*. Tweets that argue for nuance will get swamped by those that *trump up*. *Excessive outrage* gets more attention than measured calls for patience and more evidence. Refusing to engage others any further because one's claims are *self-evident* is fostered by a cheering crowd giving out hearts for bold claims and a technological platform that favors speed and style over substance.

That's a problem. Tosi and Warmke argue that grandstanding is morally problematic in a few ways. Someone who grandstands doesn't contribute to moral discourse; they're not aiming at convincing people about right or wrong, but about whether they're a morally respectable person. The trouble is that in grandstanding they take care to look as though they are contributing to moral discourse. The result is cynicism about moral discourse.[30] We also might suffer outrage fatigue, as being perceived as morally respectable requires us

to be ever more outraged about moral affairs. Consider the backlash actor Matt Damon endured when he suggested in an interview that the #metoo movement wasn't distinguishing carefully enough between people who had sexually assaulted others and people who were guilty of far less serious crimes, and that a payout wasn't necessarily evidence of guilt. People reacted angrily and piled on.[31] Being morally respectable on Twitter means being always outraged. And finally, ramping up and trumping up lead to more polarized discourse, as people try to outdo each other with more extreme positions.[32]

Philosopher Neil Levy argues that Tosi and Warmke overlook the positive functions of grandstanding, which he calls "virtue signaling," on our moral discourse. Virtue signaling provides a kind of metacommentary on moral discourse, by conveying not only the number of people who share a view, but how confident they are in holding it.[33] Those are relevant considerations when we try to assess ethical evidence. Moreover, grandstanding can signal that someone is trustworthy; grandstanding about morally compromised artists could signal that someone is genuinely committed to fighting sexual harassment and assault. Levy concludes that moral grandstanding, rather than being opposed to moral discourse, is invaluable to it. It shapes the norms of the moral community. We saw in Chapter 3 that one of the functions of actions like boycotting artists can be to signify the boundaries of acceptable behavior.

Levy argues that deceptive signals – where one engages in virtue signaling but doesn't mean it – are "somewhat difficult to fake." For most of human history, where one's audience was small and intimate, signaling one's virtue was costly. One would have to expend resources (e.g., wearing special religious garb, forgoing certain foods, remaining sober at

the harvest festival, etc.) and maintain one's reputation over time by continuing to signal virtue. Faking virtue would be too hard because virtue signaling evolved in an environment where faking it was too costly to try.

Social media, however, makes it much easier to mimic genuine virtue signaling. Levy argues, on the contrary, that the evidence shows that most people who virtue signal *do* possess the emotional response that they express. They're not faking outrage. They're not faking concern. It is easier to fake on social media, but Levy argues that it hasn't been around long enough for it to affect the circumstances under which we signal virtue.

Suppose for the sake of argument that he's right that most people don't disingenuously grandstand on social media. I suggest, however, whether they're faking it is somewhat beside the point, because the mechanism that leads to the drawbacks of grandstanding, such as piling on, ramping up, and trumping up, does not seem to be sensitive to whether someone's grandstanding is genuine. The result is often that while one may have meant only to grandstand a little, the resulting consequences far exceed what anyone would have wanted. In small social groups where grandstanding putatively evolved, it's reasonable to suppose that the close-knit nature of the social group would have served as a check on overzealous grandstanding. ("Who are you to condemn him? We all saw you drunk off your gourd at the harvest festival.") The grandstander also would likely have a prior personal relationship with the group and the target of their grandstanding. There would be an emergency brake on their behavior. On the Internet, however, our imagined communities have no controls on grandstanding, and it can rapidly spiral out of control.

Here's a case that predates the #metoo movement (and the term "canceled"), which illustrates the mechanism well. In 2013, Justine Sacco, a PR coordinator traveling to South Africa from New York, tweeted mordant observations shortly before her eleven-hour flight, including "Going to Africa. Hope I don't get AIDS. Just kidding. I'm white!"[34] The tweet, Sacco says, was "making fun of the bubble" in which most Americans live; presumably, mocking the sort of dimwitted people who would think that going to Africa on a plane automatically increased one's risk of contracting AIDS. Twitter, however, took the tweet as evidence of racism. Sacco boarded her flight, where without Internet access she was unaware her tweet had gone viral. By the time she landed, #HasJustineLandedYet was trending, a Twitter follower showed up at the airport to snap her picture, and three weeks later she was fired from her job. Seven years later, her career moves still make headlines.

Moral grandstanding drove the response to Sacco's case. Those who *piled on* and *ramped up* were rewarded with Twitter hearts and retweets. One wonders what would have happened had her flight been delayed, where she would have responded to criticism before the initial tweet went viral. Those who participated in the shaming of Sacco may have been genuinely upset with her behavior, but one wonders if those who gleefully watched the storm unfold would have, off of Twitter, believed that the punishment for a thoughtless tweet should have been years of un- and under-employment.

The point of talking about morality is to make us into better people by improving our beliefs and our behavior. The point of the good kind of virtue signaling that Levy endorses is to function as a kind of metacommentary on our moral standards, to set the tone. The problem is that the speed and incentives of social media do not reward taking time to think

about what one wants to signal. Not only does social media push our opinions toward the extremes and silence moderating voices, but it does so in the expectation that success means going viral very quickly. If someone takes the time to think about whether they ought to cancel an artist, they'll lose their chance.

#NotAllCancellation is bad. One could judiciously use social media to reach millions of people to promote a cause that one genuinely supports. It's plausible to think that the founders of #MuteRKelly and #TimesUp, for example, aren't grandstanding because they're also running charitable and legal foundations aimed at helping victims. They also work in the industry, and so it's more plausible that their signaling helps to change norms for the better. The average person who tweets or 'grams themselves in support of canceling an artist, however, is at a higher risk of grandstanding. The tag they happen to see, the immediate demand for a response, the heightened emotions – none of this rewards careful thinking, and all of it rewards grandstanding.

IV.

In most of this book, I've focused on the question of whether we must stop engaging with the work of morally compromised artists, and on balance, my answer has been that most of the time, it does not matter all that much what we choose. With all that we've considered in the chapter, what's the final verdict on cancellation? What should a conscientious fan do?

When we consider just the consequences of most cancellations, one might conclude that participating in cancellation is usually ethically permissible because it's relatively harmless. Sometimes the mob gets out of control, as in Sacco's case. If you support a given cancellation and give it

your voice, you're participating in an event whose consequences may range far beyond what you think is just or fair. Clearer heads aren't going to prevail because they're going to be shouted down.

Cases like Sacco's, however, are relatively rare. It's hard to figure out exactly how much being canceled harms artists. Most attempts at cancellation don't seem to work unless they're accompanied by actual legal action. In the cases where there is legal action taken, as in Cosby and Weinstein's case, the effect of the legal system is going to swamp whatever effects a grassroots social media group is going to have. Canceling Harvey Weinstein does nothing that a stay at Rikers won't do. If one participates in a cancellation where there isn't also a parallel legal case, the odds are very good that the practical effect on the cancellee is nil. Most attempts at cancellation are less successful than commercial boycotts.

Nevertheless, there are some reasons to think that cancellation isn't ethically neutral apart from its effects. Participating in cancellation requires not just boycotting the artist but declaring that one is participating in a cancellation, and, as it's practiced, doing so by posting about it on social media and tagging it with a hashtag. I've argued that doing so is a pernicious form of moral grandstanding, and should be avoided. It makes us worse at evaluating reasons because we care about how others perceive us instead of aiming at truth. Grandstanding is also a poor substitute for genuine moral discourse. Our collective attention span is short, especially when mediated by a tiny Twitter box or an Instagram post, and thoughtful moral discourse gets crowded out by grandstanding. If we grandstand, we make ourselves a tiny bit morally worse, and make the public discussion of morality a tiny bit worse, too. The effect is small but definitely negative.

You're not a bad person for grandstanding on the Internet, but maybe you're not as good as you could be.

As casual fans, then, we should think hard before signing on to an attempt to cancel an artist. First, we should consider that it's not possible to call back a mob once it's started. Here's a rule of thumb: imagine that the call for cancellation actually gets traction, and you're reflecting on it six months later. It's worked as promised; the artist is in celebrity exile, with no obvious way back. If it seems as if that would be an ethical outcome, then sign on; but I suspect that most of the time we'll find that the offense simply isn't that serious.

Second, we can take time to wait, especially if the call for cancellation results from a feverish bombshell of a story. Is Disney director James Gunn a pedophile? One might have thought so from the initial press, but within a day it was clear that he was guilty only of making inappropriate jokes a decade ago. Waiting gives us time to learn more and reduces the risk that we're grandstanding.

Finally, we can keep in mind that we can always simply decide not to engage with an artist's work without publicizing that we're doing so. If the point of cancellation is to deny someone money and attention, and I read an article or Twitter thread that brings a morally compromised artist to my attention, believe it or not, I can refuse to engage with their work without posting about it on social media. This suggests a useful thought test. Imagine that you could decide not to engage with the artist's work, but only on the condition that you couldn't publicize that you were doing so on social media. (We'll assume that you're a social media nobody, so any virtue signaling from you will be lost as noise.) No changing your Facebook profile picture, no poignant Instagram snap of you deleting them from your Spotify feed, no tweets, no Tiktok.

Would you still feel the pull to disengage? If you do, it's a good sign that you're genuinely repulsed by the artist's behavior. If you don't, it's reasonable to think that you're motivated less by thinking that the artist needs to be punished and more by your own need to grandstand.

Unsurprisingly, debates over the ethics of cancellation online themselves are subject to grandstanding and thus lead to the same polarization of opinion that Tosi and Warmke predict. Probably the only sensible thing to do is leave Twitter. But let me be clear: participating in cancellation in many cases is ethically wrong, but most of the time it's not a terribly big ethical wrong. Still, jumping on bandwagons is unwise, especially if one suspects they might hurtle over cliffs. Consider cancellation cautiously.

Six

I.

Suppose we conclude that it's OK to enjoy the artwork of immoral artists. Are we as ethically bankrupt as Paul Gauguin?

Let me explain. Nineteenth-century artist Paul Gauguin achieved long-desired fame after moving to Tahiti in the hopes of finding a primitive paradise that would reinvigorate his art. In this he succeeded. His bold and colorful Post-Impressionist paintings of Native Polynesian women conveyed serenity and union with nature. His interest in primitive art would influence the French avant-garde movement and Pablo Picasso. Museums still exhibit his work.

Yet Gauguin's artistic success came with an ethical price. In moving to Tahiti, he abandoned his wife and children. In Tahiti, he pursued a series of sexual relationships with young teenagers, who were often the nude subjects of his paintings, and abandoned the resulting children. It's likely that he also infected them with syphilis. Many art critics today recognize his artistic gaze as irredeemably colonialist, as his paintings unjustly represent Tahiti as a savage garden and its inhabitants as exotic and unindividuated nude brown bodies.

Gauguin is philosophically interesting for another reason. Philosopher Bernard Williams imagines a lightly fictionalized Gauguin reflecting on what counts toward his life being a success. Gauguin, on Williams' analysis, has a vision of how

his life should go. He's committed to an aesthetic project as a painter, and pursuing that project gives him reasons for action: to move to Tahiti, to experiment with color and pigment, to adopt certain habits of lifestyle and dress, among others. The result is that Gauguin is insensitive to the ethical implications of his decision to leave his wife and children. The only reasons that matter to Gauguin concern the success of his painting career.[1]

It's safe to say that none of us who count ourselves as fans of immoral artists are as monomaniacal as Gauguin was, but our aesthetic projects, which may include appreciating the work of immoral artists, generate aesthetic reasons for aesthetic action. The beauty of a sunset provides an aesthetic reason for me to appreciate it. Aesthetic projects also generate other aesthetic reasons for taking aesthetic actions such as *curating, preserving, educating,* and so forth. If I've decided to pursue an aesthetic project, I will find myself with new aesthetic reasons for undertaking aesthetic actions.

Here's why I'm worried that we make Gauguin's ethical error. So far, we've mostly conceived the ethical debate over immoral artists as if we're loading a philosophical balance scale. On one side, we set the expected results of continuing to engage with the artwork of immoral artists: the pleasure we get from enjoying the art, or the aesthetic value we derive from pursuing our aesthetic project, minus the harm that we'd do or in which we might be complicit. On the other, the expected results from giving up the artwork. When we imagine setting up the scale this way, we imagine doing so from a neutral standpoint, and we correspondingly think of the aesthetic and ethical reasons as shared reasons. Everyone feels the pull of both the aesthetic reasons and the ethical reasons, and then we decide which wins out.

Williams developed the example of Gauguin's decision to explain that framing the ethical puzzle this way badly misses the point. It would be absurd to argue that it is ethically permissible for a man to abandon his wife and children only if it turns out that he'll be a great artist. As Williams writes, apart from any concern about the absurdity of the claim, it's also impossible for Gauguin to know whether he'll be a great artist at the time he makes the decision to leave.[2] This framework, moreover, doesn't capture how reasons work. Sometimes, when we have a reason to do something, the reason figures into our motivation to undertake an action. We feel the pull of the reason; it inclines us one way or another toward an action. Suppose I am lying lazily in bed one morning when my alarm goes off. I consider that I have a reason to get up and start my day: I have a lot to get done, and none of what I want to accomplish will happen unless I get moving early. I also have reasons to stay in bed: I'm tired, and I'm comfortable where I am. The reasons incline toward getting up or going back to sleep, and what I decide to do will depend on what reason wins out.

The big philosophical question here is whether reasons *always* motivate us to act, or whether there can be reasons that nevertheless fail to move us. It's a subtle difference but important. Suppose that my son ought not to slug his little sister when she pesters him. I tell him that it is wrong to hit his sister because it is wrong to hurt others, but he is not motivated to act. An externalist about reasons would say: he still has a *reason* not to hit his sister, because it is wrong to hit other people even when they pester you. An internalist about reasons would say: he doesn't have a *reason* even though it is wrong to hurt others, because he isn't motivated to act. The latter position is known as *reasons internalism*

and it does what it says on the package. Something is a reason only if it motivates us to act. That means that whether a fact ("hitting hurts your sister") counts as a reason for someone depends on the motivations and desires that they already have.

Many people find reasons internalism to have bad counterintuitive consequences. If someone isn't motivated by ethical considerations, then reasons internalism says that they don't have ethical reasons to act. They're not making the ethical mistake of failing to pay attention to reasons, because for them, there are no reasons. That doesn't seem right. Gauguin's failure to consider the worth of his wife and children in his plans (not to mention the statutory rape, abandoned children, and probable syphilis transmission) sure seems like an *ethical failure to consider reasons*. Gauguin might well justify his decision to himself in terms of his hopes for artistic success, but it also seems like he's wrong because he has *other reasons he should consider*.

Philosopher Kate Manne defends a more palatable version of reasons internalism that makes use of a philosophical distinction between the *interpersonal* stance and the *objective* stance. Think of these as attitudes which we might take toward someone. If I adopt the interpersonal stance toward you, I'll treat you as someone with whom I can profitably have a discussion. I'll expect that I can offer your reasons, and I might hope to change your mind. I might do this by appealing to your values or giving you reasons in the form of facts that you hadn't considered but will recognize as important. By contrast, if I adopt the objective stance, I'm interested not in your reasons but in managing your behavior, perhaps by giving you an order or coercing you. You're a problem to be solved.

We switch between the stances as needed. Manne argues that when we deliberate with someone and offer them reasons for what they should do, we adopt the "interpersonal standpoint." We treat them as persons, as beings who are going to be responsive to reasons. A parent of a stubborn toddler might begin in the interpersonal stance when they attempt to convince the child to put on their shoes, appealing to their motivations and desires. *Don't you want to wear shoes? You need your shoes so that we can go to the park and see Grandma.*

The facts that will move someone depend on what they already value and desire. The parent offers the fact that Grandma will be at the park to persuade the toddler who already has the desire to see Grandma. Manne acknowledges, however, "that there may be real limitations on what can be said and done, which we might have hoped could be said and done, within the interpersonal activity of reasoning with an agent."[3] If we reach those limitations, we will shift from deliberating with them as persons, and treat them in the objective stance. If the child's stubbornness continues, the desperate parent, looking frantically at the time, might switch to the objective stance, sweeping up the child, depositing them in the stroller, and putting the shoes on their feet. (It's not strictly required that the objective stance involves howling and tears, but it's often the consequence.)

Now imagine that you argue with Gauguin as he boards the boat to Tahiti. You remind him of his obligations to his wife and children; you press upon him the importance of keeping those obligations. Gauguin doesn't listen; he's insensitive to any consideration that doesn't tell him to test his fortune across the sea. You might think "he won't listen to reason," but it would be more accurate to say that you haven't successfully given him a reason. Your argument didn't worm its way into his motivations.

According to Manne, switching to the objective stance doesn't mean giving up on ethical responsibility. This is what saves her view from the common objection I raised earlier. We can still hold people ethically blameworthy for being insensitive to reasons. Gauguin should be motivated to accept the facts we've told him as *reasons*. He ought to be the kind of person who cares about his wife and children, and he's not.[4] We can still try to change him, but we're no longer deliberating with him. We might try to change his motivational structure (perhaps by sending him to therapy, or having him watch dramas about midlife crises, or shouting at him a lot) or ignore him and turn our ethical focus to helping his wife and children. But he is still accountable, on the assumption that he's chosen to be the way he is. It would be ethically better if he were otherwise.

Echoing Manne and Williams, Philosopher Daniel Culcut doesn't mince words:

> You might get to Tahiti, fail at your work, and discover that you are not a great artist after all. You are merely a shit. Your ground project in life, your art, might be based on an illusion, even if your deepest impulse is to pursue it.[5]

Manne concludes that reasons internalism is sad but true. Our ability to persuade someone to be good will be limited by who they are, and what they already value. We don't all share the same desires and motivations because the desires and motivations that we have depend in part on how we have decided that our lives should go. As Williams observes, we don't plan our lives by determining in the abstract what kind of life would be best for us. Rather, the sort of life we decide to lead "conditions

our later desires and judgments."[6] For example, I want to write this book not because I sat down one day and decided that it was, from a hypothetical neutral standpoint, the use of my time that would bring the greatest amount of happiness to the greatest number. Rather, my decision to write the book fell out of a much earlier decision to become an academic, which has shaped my desires and motivations such that spending weekends writing public philosophy sounds like a great time rather than a chore. If I had different desires and motivations, I'd have no reason to write the book.

Now we can put the concern of this chapter more plainly. Those of us who have taken up significant aesthetic projects are often loath to give them up. They matter to us, and provide us with aesthetic desires, aesthetic reasons, and aesthetic motivations. Suppose we're not moved by the ethical facts about an artist's bad behavior. It's not just that as it turned out, the good we'd do by boycotting artists was negligible. It's that having an aesthetic project meant that the artist's wrongdoing didn't really count as a *reason* to give up their artwork.

We're probably not as bad off as Gauguin, whose single-minded pursuit of artistic success left him insensible to his ethical obligations to his wife and children. We still recognize the pull of ethical reasons. But we might worry that loving art makes us worse people by complicating what should have been an easy ethical decision, by *muting* our ethical impulses. Suppose that it's true for some fans that their aesthetic projects generate internal aesthetic reasons that outweigh ethical reasons that would move other people to boycott an artist. That looks not like a *defense* of aesthetic projects but like an indictment of them.

Moreover, there's a good case to be made that *aesthetic reasons* are internal in the way Williams describes. A fact, such as

the bright colors of a sunset, generates an aesthetic reason for us to act only if we have the right motivational structure; we have to be open to appreciating it. If we are motivated to appreciate beauty, then the beauty of the sunset is a reason for us to stop and admire it. If we lack those motivations, then the facts about the sunset don't amount to aesthetic reasons.

Of course, some of the motivations and desires that generate aesthetic reasons are external, or very close to it. Human beings like symmetry, elegance, beauty, and so forth and we're drawn to it. If you describe a flower, painting, or sonnet as beautiful, I find myself nearly automatically with an aesthetic reason to check it out. Nevertheless, many aesthetic reasons seem to be internal. The choice to engage with an artwork needs to be the natural result of deliberation based on desires and motivations that we already have. If someone is open to new musical experiences, then they have a good reason to listen to avant-garde jazz. Desiring a bold sense of style likewise gives them a reason to wear glitzy chandelier earrings. Enjoying the experience of learning salsa dancing might motivate someone to branch out into Argentinian tango. If someone doesn't already have the appropriate desires and motivations, however, there doesn't seem to be much we can do to persuade them otherwise. We can give them *facts* about jazz or trends in earrings or forms of dance, but we can't give them *reasons* unless they are already primed by their motivations and desires to accept the facts as reasons.

Recall from the first chapter that when we choose a specific aesthetic project, we find ourselves with new aesthetic reasons to act. Wanting to dance classical ballet at the highest level gives a dancer a reason to develop the skill required to practice the exceedingly difficult turns called fouettés. These aesthetic reasons move us to act – but they're reasons

only in those cases where someone has adopted an aesthetic project which grounds them. They're not aesthetic *reasons* for anyone on the outside. I can recognize that fouettés are an achievement, difficult, proof of strength and grace, and beautiful, but there is no aesthetic reason for me to practice fouettés because I haven't adapted performing classical ballet as an aesthetic project. The beauty of the ballerina's art isn't enough of a reason (fortunately) for me to start practicing turns in my office.

The problem with the standard utilitarian framing of what to do about the work of immoral artists is that it treats all aesthetic reasons and ethical reasons as if they are on a par. What this overlooks is that people who don't have the relevant aesthetic motivations and desires simply won't recognize the aesthetic reasons as reasons. By contrast, people who have adopted an aesthetic project will find themselves with new motivations and desires, and corresponding new aesthetic reasons. There's no neutral standpoint because whether aesthetic considerations count as reasons depends significantly on the projects one has adopted.

Someone who has adopted an aesthetic project has access to a new realm of value, motivation, desires, and aesthetic reasons. In doing so, they gain reasons for action that compete with ethical reasons. Someone who has made a project of studying the music of Motown has an aesthetic reason to listen to Michael Jackson, one that I've argued outweighs the teeny amount of good they might do by boycotting Jackson. Someone external to that project, however, doesn't have the same aesthetic reasons. If the two meet to try to decide whether it's OK to listen to Michael Jackson, they won't share the same set of reasons. The fan of Michael Jackson isn't weighing the same set of concerns as the non-fan.

We've returned, in a roundabout way, to the question of moral sainthood. The moral saint would eschew any aesthetic projects because they would conflict with the good. The moral saint's life seems to be too extreme, but so does the life of Gauguin, who ignored the demands of ethics entirely in pursuit of his Tahitian vision. How are we to balance pursuing our aesthetic life against pursuing our ethical life? We don't want to be mere shits, even if we're stylish.

II.

Let me develop the case that aesthetic reasons internalism is true, but not all that sad. First, choosing an aesthetic project can be a radically transformative experience, and this explains why some aesthetic desires and motivations are internal. Second, some of the time, choosing an aesthetic project leads us to care more about ethical questions, making us more thoughtful people.

Aesthetic projects can be transformative because some of the aesthetic reasons and values that we'll hold will arise only after we've chosen the project. We might choose an aesthetic project without much conscious thought beyond aesthetic appreciation: a snatch of a song overheard at a bar, a taste of a premium coffee expertly brewed, a watercolor class taken just to fill out one's school schedule. Yet if we continue with it, we might find that with time, we've developed new desires and motivations that thoroughly surprise us. We devour an entire genre of pop music; we start roasting our own coffee from artisanal beans sourced online; or we find ourselves with what would have seemed to our previous selves to be absolutely gonzo opinions about the quality of squirrel hair paintbrushes.

We cannot always anticipate the changes an aesthetic project will bring to our desires, motivations, and priorities. The

radical potential of choice isn't unique to aesthetic projects. We can see it illustrated in a short passage from Ted Chiang's science fiction short story *The Lifecycle of Software Objects*. In the story, an animal trainer named Ana accepts a job at a software firm that produces *digients*, cute, affectionate, toddler-like digital artificial intelligences that can learn and grow, to be sold as digital pets to people who will take care of them. As the story progresses, Ana and the community of digient caretakers discover that they have grown to care about the digients, and they nurture them as if they were young children. Ana ruefully reflects that the centrality of the digients to her life has added a challenge to her love life:

> "It's hard to find someone who understands," Ana says. "It was the same when I worked at the zoo; every guy I dated felt like he was coming in second. And now when I tell a guy that I'm paying for reading lessons for my digient, he looks at me like I'm crazy ... Although I guess I really shouldn't blame them ... It took me a while to understand the appeal myself."[7]

Ana's decision to commit to the project of rearing a digient gives her reason to pay for reading lessons for what is essentially a pile of software code. The project comes with its own reasons for action. Anyone outside of the project – like Ana's prospective boyfriends – won't feel the motivational force of the reasons that she does. They might be able to understand the facts – that digients are sentient, and benefit from intellectual stimulation – but those facts don't count as reasons.

The only way to have those reasons is to adopt the digient project. We can trace her reasoning from the outside; we can recognize that she is acting. We can say that *Ana has reason to pay*

for reading lessons for her digients. We won't feel motivated, however, unless we adopt the project of caring for digients. Their apparent needs aren't reasons for anyone who doesn't take up the project. Similarly, Ana understands that her digient Jax is made of software code. She knows that he was designed by a software company and trained through machine learning to be adorable. She wouldn't disagree with her potential boyfriends about the facts, but the facts do not generate the same set of reasons for her that they do for them. Neither can really understand the other's reasons.

Moreover, Ana's relationship with her digient transforms her priorities. It transforms her. She could not have known, when she accepted the job, that years later she'd be concerned for the emotional health of her digient to the point that it would affect her own love life. Ana's decision to take the job at the software company first turned out to be a transformative experience. A transformative experience, according to philosopher L.A. Paul, is one where we cannot know, until we take it up, what it will be like to have that experience, or what our priorities might be after we do.[8]

One paradigmatic example of a transformative experience is having a baby. Prospective parents can read books and ask friends and family for their opinions, but they won't be able to discover what it's like to have a baby until they have one. They might expect, for example, that having a baby at first means sleepless nights; they might be surprised to discover that it's easier to endure that they thought. They might expect, from talking to friends, that they will have to give up some of their favorite hobbies; they might be surprised to discover, when their weekly soccer game falls by the wayside, that they no longer care.

Not all transformative experiences concern big life changes. Much smaller experiences, such as tasting Vegemite,

the Australian food spread made of leftover brewer's yeast, can also be transformative. I've never tasted Vegemite. One friend described it as licking the floor of a bar after last call; another laughed in a way that suggested she conceded the point but insisted that it was delicious. I cannot judge, without trying it, whether it's something I'll enjoy or something I'll detest. I can't rely on the testimony of my friends, because while they can try to tell me what Vegemite is like, I can't know in advance whether I'm the kind of person who will find it delicious or whether I'm the kind of person who will find it disgusting.

Aesthetic projects can be similarly transformative. Sometimes, they are transformative because we cannot understand the aesthetic value of the practices that make up the project until we've adopted it. Difficult art is like Vegemite. Difficult works of art are transformative because their difficulty, whether resulting from unfamiliarity on the part of the perceiver or complexity within the work, obscures their aesthetic value to those who have not experienced it. It takes knowledge, effort, and the willingness to experience the art in order to understand why it's valuable.

As a result, difficult art presents a motivational problem for the novice appreciator. The novice appreciator can't recognize the aesthetic value presented by the artwork until they've engaged with it for a while, but they have no reason to decide to engage with it, because they can't yet perceive its value.[9] The afficionado of free jazz will find it electrifying, intense, and mesmerizing; I, despite repeated attempts to listen to it with an open, appraising, and thoughtful mind, find myself desperate to identify a musical phrase and find the experience profoundly unsettling. Free jazz for me is an aural anxiety attack. Some aesthetic projects are transformative because

we cannot understand the aesthetic values and reason without adopting the project. We need to take an aesthetic leap of faith. A trusted friend might be able to coax them into engaging the artwork, but in the end, there won't be much to say beyond: Trust me. Try it. You'll understand once you do.

Not all art is Vegemite. Some art is chocolate cake; it's easy to see how it entices people. It's accessible. Yet even accessible art can still be transformative to the extent that we might not anticipate what new values an aesthetic experience will open for us. Philosopher Anthony Cross argues that our aesthetic obligations to works of art, such as engaging with them properly, grows out of our love for works of art.[10] When we love someone, we find ourselves with new reasons to act in loving ways toward them. Because I love my son and he loves to ride his bike, I have a reason to buy him a new bicycle for his birthday. The love I have for him explains my motivation. By contrast, I'm not motivated to buy him a bicycle out of a belief that in general, it is good for children to have bicycles and that as a matter of economic efficiency, each parent should purchase bicycles for their own children. Nor have I analyzed my purchasing power and determined that the most good I could do in the world is to buy this boy a bicycle. (Imagine giving either of those explanations as a response to the question of why you bought your kid a bike!) Rather, the love I have for him gives me reason to express it by supporting his favorite pastime.

Cross argues that when we love a work of art, we make a commitment to ourselves to treat it properly. Treating a work properly might be sitting before it in quiet contemplation at a museum, or blogging about it, or sharing it with our closest friends, or learning more about it. I suggest that an aesthetic project can be transformative in those cases where

we discover that the commitment we've made to ourselves to love the work leads us to develop motivations to treat the work properly in ways we could not have anticipated.

Aesthetic love can be transformative. For example, we might pick up a children's book about a boy wizard and find that the story we read shapes our aesthetic life for the next twenty years. J.K. Rowling's seven-book *Harry Potter* series chronicles the adventures of the titular boy wizard. The series is squarely aimed at older children, but it counts many adults among its fans, who are drawn not only to the charming and whimsical world that Rowling builds but to its professed moral values of tolerance, compassion, and bravery.

The books are accessible, and their initial aesthetic appeal is easy to see. Rowling combines a straightforward story about growing up and discovering who you are with a charming, creative, and witty sensibility. They're delightful. For some of us, our aesthetic engagement with the books ended there. I've read all the Harry Potter books, initially because of the opportunity they posed to bond with my then-eleven-year-old sister, who wrote me letters when I was in college about her predictions of what would happen in the next books, but the books clearly didn't grab my attention the way they did some people. The series led to eight movies, a theme park at Disney World, a Broadway-bound sequel, billions of dollars for the author, and enduring Internet fan communities.

Some fans have turned their aesthetic love for the books into community service. The 70,000 members of the Potterhead Running Club, a virtual fitness club, are united by their affection for the *Harry Potter* books. They gather on social media to share their fandom and socialize with others. The group has turned their aesthetic love for the books into an ethical drive to embody the values they see as encoded in the text. They run

virtual races regularly, and they take the values encoded in the Harry Potter books as reasons for action. Their fundraising efforts began with a virtual run that raised money for cancer treatment and rewarded participants with a medal designed in the Harry Potter aesthetic. The PHRC now works with charitable organizations to map the participants' runs and steps onto monetary donations, and as a result has donated USD $2.3 million to charity over the last five years.[11] For the members, running long distances and participating in ethical fundraising forms a way of aesthetically engaging with the books.[12]

It's fair to suppose that for the members of the Potterhead Running Club, the choice to read *Harry Potter* all those years ago has been a transformative experience. I suspect if you'd asked most of the members back in 1997 whether they thought it was reasonable to track their daily step count for charity and competition based on reading a book about wizards aimed at ten-year-olds, they'd have raised a skeptical eyebrow. Yet their aesthetic project now provides genuine motivation and genuine meaning.

Now let's return to the question of aesthetic reasons internalism. This is the "true." Some aesthetic experiences are transformative, and this introduces radical uncertainty into our ability to determine aesthetic value without taking up an aesthetic project. If reasons consist of those facts that move us to act, and some aesthetic facts move us only if we have accepted an aesthetic project, then there is a potential set of reasons that are wholly internal to an aesthetic project. For someone outside the project, some aesthetic facts won't be reasons to act at all. Those enamored with their aesthetic project will likely take their aesthetic values and reasons seriously. As a result, they might reach a different conclusion when asked to weigh their aesthetic values against the putative ethical value

of giving up an artist's work in protest. For someone outside of the project, the aesthetic value is small and the aesthetic reasons non-starters. For someone whose life has been transformed by the aesthetic project, the aesthetic value is great, the reasons compelling, and the call to boycott evidence that the other person just doesn't get it.

Here's why it's not "sad." Aesthetic projects also often provide additional ethical reasons for acting. For most of this book, we've presumed that the ethical dimension of the problem of immoral artists is largely something that works *against* fans of the work. It's the gushing fans of Woody Allen reminiscing about the incandescence of *Annie Hall* versus the sober-headed people who just want Allen to face justice. What this framing ignores, however, is that the love one has for a work of art can drive one to stake an ethical claim.

Arguably, we care more about the ethical behavior of artists when we care about their work. While I can only speculate, I suspect that something like a feeling of contamination underlies some of the strength of the reaction of fans when they learn that a favorite artist has committed horrible actions. The artist's crimes seem to poison personal memories that were intertwined with the artwork. For years, my family laughingly told of the time I drew a picture of Michael Jackson with his hair on fire. In 1983, Michael Jackson was severely injured during the filming of a Pepsi commercial when the pyrotechnic spectacular ignited his hair. I was little, just four years old. I must have overheard the evening news. I don't remember drawing the picture, but I've seen it, an otherwise unremarkable kid's drawing, all manic black lines and vivid orange flames. My mother kept it for years, tossing it only after the latest allegations came to press (and before I could steal the image for this volume! Thanks, Mom). If we didn't

love their artwork, we wouldn't care nearly as much about what they'd done.

The love we have for an artwork, however, doesn't need to lead us to excuse or ignore an artist's wrongdoing. It can prompt ethical action. Let's return to our *Harry Potter* fans. In response to a headline in the summer of 2020 that referred to "people who menstruate," rather than "women," Rowling tweeted in response that "there used to be a word for those people. Someone help me out. Wumben? Wimpund? Woomud?" She followed it up with a series of tweets where she explained that she believed that transwomen, people designated male on their birth certificate and who affirm their gender identity as women, are not real women. After significant public outcry from transwomen and their supporters she doubled down in an essay posted on her website. As I write this, the Rowling incident is still unfolding.

As someone who liked the Harry Potter series well enough but who hardly qualifies as a fan, I watched the unfolding Twitter drama with only academic interest. Rowling's opinions aren't any more important to me because of her status as an author whose books I read more than a decade ago. Even if I believed a boycott could be an effective pressure on her and I had some way of boycotting her (burning the books I bought for my little sister in 2001?), and even though I disagree with her, I don't register her tweets as demanding a special ethical response from me.

Things aren't so simple for those for whom *Harry Potter* is a serious aesthetic project. The three lead actors in the movies based on the books publicly rejected Rowling's words and reaffirmed their support for LGBT+ causes. Fan communities deliberated about what ethics required of them. The two biggest fan sites, *The Leaky Cauldron* and *Muggle.net*, divested

themselves from Rowling herself. The editor of *Leaky Cauldron*, Melissa Anelli, released a public statement that read in part:

> Although it is difficult to speak out against someone whose work we have so long admired, it would be wrong not to use our platforms to counteract the harm she has caused. Our stance is firm: Transgender women are women. Transgender men are men. Non-binary people are non-binary. Intersex people exist and should not be forced to live in the binary. We stand with Harry Potter fans in these communities, and while we don't condone the mistreatment JKR has received, we must reject her beliefs.[13]

Loving the *Harry Potter* books and movies gave *The Leaky Cauldron* more ethical reasons to care about Rowling's beliefs. Loving the books may have given some fans more reason to contemplate the challenges facing transgender men and women than they would have had otherwise.

So, I'm an optimist. Manne argued that if someone's motivations precluded reasoning with them in the interpersonal stance, we'd have to treat them in the objective stance, as a problem to be managed. That seems right in the fictionalized case of Gauguin. Fictionalized Gauguin doesn't listen to ethical reasoning and refuses to care for his wife and children, and there's nothing that we can do to motivate him. Yet while I agree that the interpersonal stance has its limits, I think we can take comfort in the fact that aesthetic projects, like our individual projects, sometimes produce internal ethical reasons for acting. Aesthetic projects can motivate *more* ethical concerns, and license stronger ethical actions. This isn't a reason for despair, but for hope!

For example, the members of *The Leaky Cauldron* have more options open to them than boycotting or not boycotting. By

severing ties with the author and doubling down on their commitment to making their community as welcoming as possible, they use Rowling's tweets as a springboard for improving their aesthetic community. From the perspective of a serious Harry Potter fan, someone like me who just doesn't quite get why anyone cares about Rowling's opinions these days is missing the point of how hurtful her comments could be to the community that loves the books. From their perspective, perhaps I am nothing more than a problem to be managed.

We can extend the lesson from The Leaky Cauldron to other cases. Someone whose projects involve the work of immoral artists has aesthetic reasons that might tell against giving up their work. Yet they have more ways to respond ethically than those of us whose only interactions with their beloved artists lies in appreciating their work.

For example, those of us who are mere visitors to the museum find our choices concerning Gauguin's paintings limited to either looking or not looking. Those whose aesthetic projects include his work, however, have more challenges and more opportunities for ethical responses. The curators of the National Gallery of London hosted an academic panel that directly addressed the problem of engaging the artwork of immoral artists alongside an exhibition of Gauguin's paintings.[14] Scholars trace how the savage garden Gauguin painted existed only in his colonialist imagination; the supposed exoticism of Tahiti was his own invention.[15]

Artist Tyla Vaeau, from New Zealand, created a photographic series Dee and Dallas Do Gauguin (2009) in which she superimposed the faces of her sister and friend over the faces of the subjects of several of Gauguin's paintings. The faces of Gauguin's subjects are beautiful but anonymized by the

softness of his lines; they seem to represent archetypes rather than real individuals. Vaeau's faces are individuated. Art historian Caroline Vercoe writes that "the works evoke amusement park cut-out murals, into which visitors place their heads to have their photographs taken. They are also a reminder that, for the most part, Gauguin's Polynesian subjects were real girls, who sat for him."[16] Vaeau's artwork undermines Gauguin's project of painting a primitive imaginary not by boycotting it, but by forcefully reminding the viewer that his anonymous Polynesian women were real people, someone's sisters, mothers, daughters, and friends, who deserved better treatment than Gauguin gave them.

So we should take heart. We may not be inclined to boycott the immoral artists whose work we love, but our aesthetic projects can give us new reasons for caring about our ethical lives and open new avenues for acting ethically. Viewed in this way, we've only just begun to think about the intersection of our ethical lives and our aesthetic lives. Boycotting artists is only one thin way we might respond. We can do so much more.

So what is the ethical fan to do? It's OK to enjoy the artwork of immoral artists. In place of a boycott, I suggest another ethical responsibility.

Don't minimize their crimes. Don't downplay them or try to convince yourself that what they did wasn't so bad. Confront them head-on. Take their failings as opportunities to spur your own ethical growth.

The problem of how we should respond to the work of immoral artists is rooted in our obsession with celebrities; otherwise, we would treat the news of their crimes as no more than trivia about someone very far away who once upon a time sold us something we find useful. We tend, as a culture,

to admire celebrities not just for their accomplishments but as people. Here the #metoo movement gets it right. Many of the powerful artists who have been brought down by the #metoo movement have done horrible things. Many of them got away with it for years, and they got away with it in part because we as fans were too enamored of the artists to believe anything bad about them. Sometimes we use the love of their artwork to improve ourselves ethically, but too often, we let their artwork become an excuse for their behavior. We minimize their crimes or stretch the meaning of reasonable doubt beyond all reason. We would not have wound up with the conditions that necessitated the #metoo movement if we collectively had been less prone to idolizing celebrities.

The #metoo movement awakened us to something we should have already known. Celebrity worship is unhealthy, and uncritical adulation is even worse, as it makes it very hard to hold people accountable for their misdeeds. A world where celebrities did not enjoy so much privilege is likely a world where Jackson's songs end with a sad coda in 1993 when his accusers first came forward, with him in prison, singing no more songs. A world where celebrities weren't so celebrated would be one where men in power did not think their creative and commercial success gave them the right to others' bodies.

We do not live in that world, however, and the unfortunate fact is that as fans, we cannot create that world by giving up their artwork. Over the course of the last few chapters, I've argued that it's ethically OK to enjoy the art of immoral artists. The strategy I've pursued has been to weigh the prospective ethical benefits of giving up the artist against the value of the aesthetic project that incorporates his work. Most of the time, the prospective ethical benefits are too small to warrant giving up the artwork. Boycotting an artist in order to punish

them or "send a message" likely won't work. Improving the environment for survivors of sexual violence is compatible with enjoying the art of immoral artists. We sometimes struggle to separate the art from the artist, because it's psychologically hard to do so, but that does not itself give us a reason to give them up. Participating in cancellations, steeped in the hot-take environment of social media, risks making us somewhat worse at ethical reasoning, so there is reason for us to be cautious when evaluating the cases of celebrities.

What we've learned in this chapter, however, is that reducing the entirety of the ethical dimensions of our aesthetic projects to a simple decision to boycott an artist woefully underestimates our ethical potential. Art can move us to care more about living ethically than we would have otherwise. It opens up new ways to inhabit the perspective of others, address wrongdoing, and communicate our values. Art helps us create communities and make friends. Through engaging art, we can improve ourselves and our culture while living rich and full aesthetic lives. And just maybe, if against all hope we find ourselves once again learning of the crimes of artists, we'll know how to respond.

SORRY! NO EASY ANSWERS HERE

1. "AJC's Mike Luckovich, On His Michael Jackson Cartoon." *Cable News Network*. June 26, 2009. https://newsroom.blogs.cnn.com/2009/06/26/michael-jackson-cartoon-what-do-you-think/.

2. Harris, Aisha. "She Founded Me Too. Now She Wants to Move Past the Trauma." *The New York Times*. October 15, 2018, sec. Arts. https://www.nytimes.com/2018/10/15/arts/tarana-burke-metoo-anniversary.html.

3. Elks, Sonia. "Hollywood to Nollywood: Key Moments in #MeToo's Rise As a Global Movement." *Thomas Reuters Foundation*. http://news.trust.org/item/20191015164734-xiezq.

4. A taste of the variety of philosophical opinions on the question of immoral artists: Aesthetics for Birds et al. "Artworld Roundtable: The Art of Immoral Artists." *Aesthetics for Birds (blog)*. November 22, 2017, https://aestheticsforbirds.com/2017/11/22/artworld-roundtable-the-art-of-immoral-artists/.

5. "Lewis Carroll's Shifting Reputation." *Smithsonian.com*. April 1, 2010. https://www.smithsonianmag.com/arts-culture/lewis-carrolls-shifting-reputation-9432378/.

6. Aesthetics for Birds et al. "Can We Separate the Art from the Artist?" *Aesthetics for Birds (blog)*. December 6, 2018. https://aestheticsforbirds.com/2018/12/06/can-we-separate-the-art-from-the-artist/.

7. Sibley, Frank. "Aesthetic Concepts." *Philosophical Review* 68, no. 4 (1959): 421–50. https://doi.org/10.2307/2182490.

8. Nehamas, Alexander. *Only a Promise of Happiness: The Place of Beauty in a World of Art*, New edition (Princeton University Press, 2010), 53.

9. Gaut, Berys. "The Cluster Account of Art." In *Theories of Art Today*, edited by N. Carroll, 25–45. 2000.

10. See Lopes, Dominic McIver. *Being for Beauty: Aesthetic Agency and Value*, 1st edition (Oxford: Oxford University Press, 2018), ch. 2.

11. Ibid, 24.

12. Games can be art! See Nguyen, C. Thi. *Games: Agency As Art* (New York: Oxford University Press, 2020).

13. Lopes, 126.

14. de Leon, J.M. "That Thing Called 'Beausage.'" *The Accidental Randonneur* (*blog*). March 14, 2017. https://accidentalrandonneur.wordpress.com /2017/03/15/that-thing-called-beausage/.

15. Levinson, Jerrold. "Artistic Worth and Personal Taste." *The Journal of Aesthetics and Art Criticism* 68, no. 3 (2010): 225–33, 229. https://doi .org/10.1111/j.1540-6245.2010.01414.x.

16. Riggle, Nicholas. "Levinson on the Aesthetic Ideal." *The Journal of Aesthetics and Art Criticism* 71, no. 3 (2013): 277–81.

17. Strohl, Matthew. *Aesthetic Akrasia*. Utah Valley University Aesthetics Conference, 2018.

18. Cross, Anthony. "Obligations to Artworks as Duties of Love." *Estetika: The European Journal of Aesthetics* 54, no. 1 (March 1, 2017): 85. https://doi .org/10.33134/eeja.157.

19. Riggle, Nicholas. *On Being Awesome: A Unified Theory of How Not to Suck* (New York: Penguin Books, 2017).

20. Nehamas, 83.

21. Nehamas, 86.

22. Nguyen, C. Thi. "Autonomy and Aesthetic Engagement." *Mind*. Accessed July 10, 2020, https://doi.org/10.1093/mind/fzz054.

23. Lopes, 39.

24. Bloom, Paul. The Case Against Empathy, interview by Sean Illing, January 19, 2017, https://www.vox.com/conversations/2017/1/19 /14266230/empathy-morality-ethics-psychology-compassion-paul -bloom.

WHY ARTISTS (PROBABLY) WON'T NOTICE YOUR BOYCOTT

1. Dederer, Claire. "What Do We Do with the Art of Monstrous Men?" *The Paris Review*. March 6, 2019. https://www.theparisreview.org/blog /2017/11/20/art-monstrous-men/.

Why It's OK to Enjoy the Work of Immoral Artists

2. Radzik, Linda. "Boycotts And The Social Enforcement Of Justice." *Social Philosophy and Policy* 34, no. 1 (2017): 102–22, 103. https://doi.org/10.1017/s026505251700005x.

3. Radzik, 119–20.

4. Weinstock, Daniel. "Dissidents and Innocents: Hard Cases for a Political Philosophy of Boycotts." *Journal of Applied Philosophy* 36, no. 4 (August 2019): 570–72.

5. Farrow, Ronan. "From Aggressive Overtures to Sexual Assault: Harvey Weinstein's Accusers Tell Their Stories." *The New Yorker*. Accessed April 28, 2020. https://www.newyorker.com/news/news-desk/from-aggressive-overtures-to-sexual-assault-harvey-weinsteins-accusers-tell-their-stories.

6. On the problem of not wanting to be a "sucker" see: Sen, Sankar, Zeynep Gürhan-Canli, and Vicki Morwitz. "Withholding Consumption: A Social Dilemma Perspective on Consumer Boycotts." *Journal of Consumer Research* 28, no. 3 (2001): 399–417. https://doi.org/10.1086/323729.

7. Parfit, Derek. *Reasons and Persons* (Oxford: Oxford University Press, 1986), 86.

8. Tannsjo, Torbjorn. "The Morality of Collective Actions." *The Philosophical Quarterly* (1950-) 39, no. 155 (1989): 221–28, 223. https://doi.org/10.2307/2219640.

9. See also Budolfson, Mark Bryant. "The Inefficacy Objection to Consequentialism and the Problem with the Expected Consequences Response." *Philosophical Studies* 176, no. 7 (October 2018): 1711–24. https://doi.org/10.1007/s11098-018-1087-6.

10. Greenburg, Zack O'Malley. "Michael Jackson At 60: The King Of Pop By The Numbers." *Forbes Magazine*. August 29, 2018. https://www.forbes.com/sites/zackomalleygreenburg/2018/08/29/michael-jackson-at-60-the-king-of-pop-by-the-numbers/#3ebd927b72ed.

11. Sehgal, Kabir. "Spotify and Apple Music Should Become Record Labels so Musicians Can Make a Fair Living." *CNBC*. January 26, 2018. https://www.cnbc.com/2018/01/26/how-spotify-apple-music-can-pay-musicians-more-commentary.html.

12. Dubner, Stephen J., and Greg Rosalsky. "Do Boycotts Work? (Ep. 234)." *Freakonomics*. Accessed April 29, 2020. http://freakonomics.com/podcast/do-boycotts-work-a-new-freakonomics-radio-podcast/.

13. Mcdonnell, Mary-Hunter, and Brayden King. "Keeping Up Appearances: Reputational Threat and Impression Management after Social Movement Boycotts." *SSRN Electronic Journal* (2013): 390. https://doi.org/10.2139/ssrn.2227090.

14. On spirals, see Glover, Jonathan, and M. J. Scott-Taggart. "It Makes No Difference Whether or Not I Do It." *Proceedings of the Aristotelian Society, Supplementary Volumes* 49 (1975): 171–209, 179–81.

15. Houck, Brenna. "Why the World Is Hating on Plastic Straws Right Now." *Eater.* July 12, 2018. https://www.eater.com/2018/7/12/17555880/plastic-straws-environment-pollution-banned-alternatives-ocean-sea-turtle-viral-video.

16. Geimer, Samantha, Lawrence Silver, and Judith Newman. *The Girl: a Life in the Shadow of Roman Polanski* (London: Simon & Schuster, 2014).

17. "Samantha Geimer Tells Her Side of Story in Roman Polanski Case." *Los Angeles Times.* September 16, 2013. https://www.latimes.com/entertainment/la-xpm-2013-sep-16-la-et-jc-geimer-book-20130916-story.html.

18. Mitchell, Victoria Coren. "Roman Polanski and the Sin of Simplification | Victoria Coren Mitchell." *The Guardian.* September 28, 2013. https://www.theguardian.com/commentisfree/2013/sep/29/roman-polanski-samantha-geimer.

19. Hamilton, Jack. "There's No Separating Michael Jackson's Music From His Obsession With Children." *Slate Magazine.* February 27, 2019. https://slate.com/culture/2019/02/michael-jackson-music-children-obsession-separating-art-from-artist.html.

20. Lepora, Chiara, and Robert E. Goodin. "Complicity and Its Conceptual Cousins." *On Complicity and Compromise* (2013): 31–58. https://doi.org/10.1093/acprof:oso/9780199677900.003.0003.

21. Radzik, 110.

22. Harris, Hunter. "Two Women Describe Louis C.K.'s 'Uncomfortable' Comedy Cellar Set." *Vulture.* August 29, 2018. https://www.vulture.com/2018/08/louis-ck-comedy-cellar-women-describe-rape-whistle-joke.html.

23. Maddaus, Gene. "Michael Jackson Accusers' Lawsuits Revived by Appeals Court." *Variety.* January 3, 2020. https://variety.com/2020/biz/news/michael-jackson-appeals-court-james-safechuck-wade-robson-1203456204/.

EPISTEMIC INJUSTICE, JERKS, BOYCOTTS, AND YOU

1. Planty, Michael, Lynn Langton, Christopher Krebs, and Hope Smiley-McDonald. "Female Victims of Sexual Violence, 1994-2010." *Bureau of Justice Statistics* (March 2013): 7 https://www.bjs.gov/content/pub/pdf/fvsv9410.pdf.

2. "The Facts Behind The #MeToo Movement: A National Study on Sexual Harassment and Assault." *Stop Street Harassment*. February 2018. http://www.stopstreetharassment.org/wp-content/uploads/2018/01/Full-Report-2018-National-Study-on-Sexual-Harassment-and-Assault.pdf.

3. Grice, H.P. "Logic and Conversation." In *Syntax and Semantics* 3, edited by Peter Cole and Jerry Morgan, 41–58. Elsevier, 1975.

4. "A Michael Jackson Timeline." NPR. June 26, 2009. https://www.npr.org/templates/story/story.php?storyId=4702126.

5. Dwyer, Colin. "The Harvey Weinstein Trial: A Brief Timeline Of How We Got Here." NPR. January 22, 2020. https://www.npr.org/2020/01/22/798222176/the-harvey-weinstein-trial-a-brief-timeline-of-how-we-got-here.

6. "Timeline: Bill Cosby: A 50-Year Chronicle of Accusations and Accomplishments." *Los Angeles Times*. September 25, 2018. https://www.latimes.com/entertainment/la-et-bill-cosby-timeline-htmlstory.html.

7. Fricker, Miranda. *Epistemic Injustice: Power and the Ethics of Knowing* (Oxford: Oxford University Press, 2011), 17.

8. Ibid.

9. Ibid, 23–27.

10. Ibid, 86–88.

11. Ibid, 17.

12. Ibid, 155.

13. Yap, Audrey S. "Credibility Excess and the Social Imaginary in Cases of Sexual Assault." *Feminist Philosophy Quarterly* 3, no. 4 (2017): 14. https://doi.org/10.5206/fpq/2017.4.1.

14. Broder, John, and Nick Madigan. "Michael Jackson Cleared After 14-Week Child Molesting Trial." *The New York Times*, June 14, 2005. https://www.nytimes.com/2005/06/14/us/michael-jackson-cleared-after-14week-child-molesting-trial.html.

15. Greenburg, Zach O'Malley. *Michael Jackson, Inc.: the Rise, Fall, and Rebirth of a Billion-Dollar Empire* (New York: ATRIA Books, 2017), 159.

16. Greenburg, 162.

17. Fricker, 92–95, 169.

18. Ivanhoe, Philip J., and Van Norden Bryan William. *Readings in Classical Chinese Philosophy* (Indianapolis: Hackett Publ., 2007), xx.

19. Anderson,Elizabeth. "Epistemic Justice as a Virtue of Social Institutions." *Social Epistemology* 26, no. 2 (2012): 163–73, 168. doi:10.1080/026917 28.2011.652211.

20. Wolf, Susan. "Moral Saints." *The Journal of Philosophy* 79, no. 8 (1982): 419. https://doi.org/10.2307/2026228.

21. "Don't Let the Good Life Pass You By." *The Good Place*. NBC. November 15, 2018.

22. See Aesthetics for Birds, Eva Dadlez, David Heti, Shen-yi Liao, Stephanie Patridge, Matthew Strohl, and Mary Beth Willard. "Can We Separate the Art from the Artist?" *Aesthetics for Birds* (blog). December 6, 2018. https:/ /aestheticsforbirds.com/2018/12/06/can-we-separate-the-art-from -the-artist/; "Does #MeToo Mean the End of the Rock'n'roll Groupie?" *The Irish Times*. March 19, 2018. https://www.irishtimes.com/culture/ music/does-metoo-mean-the-end-of-the-rock-n-roll-groupie-1.3 429670;

 Johnston, Maura. "Ryan Adams, Music's #MeToo Reckoning, and Who Really Cleans Up After Rock's So-Called Excess." *Vanity Fair*. Accessed July 24, 2020. https://www.vanityfair.com/style/2019/03 /musics-metoo-reckoning-ryan-adams; and, McDermott, Maeve. "The Art vs. the Artist: Reckoning with My Favorite Musicians' #MeToo and Sex-Abuse Allegations." March 4, 2019. https://www.usatoday.com/ story/life/music/2019/03/04/musicians-metoo-allegations-mich ael-jackson-r-kelly-ryan-adams/3007187002/.

WHEN THE ART JUST WON'T SEPARATE FROM THE ARTIST

1. Posner, R. "Against Ethical Criticism." *Philosophy and Literature* 21 (1997).

2. Anderson, J.C., and J.T. Dean. "Moderate Autonomism," *British Journal of Aesthetics* 38, no. 2 (1998).

3. For example: Livingstone, Josephine. "Wonder Woman Is Propaganda." *The New Republic*. June 6, 2017. newrepublic.com/arti cle/143100/wonder-woman-propaganda; Adams, Thelma. "Is It Any Wonder, Woman? The Latest Comic Book Movie Has Estrogen!" *Observer*. February 13, 2018. observer.com/2017/06/wonder-woman -movie-review-gal-gadot/; Pickett, Leah. "The New Wonder Woman

Is OK with Men." *Chicago Reader.* March 9, 2020. www.chicagoreader.co
m/chicago/wonder-woman-dc-comics-patty-jenkins-gal-gadot/Con
tent?oid=26903719; Dargis, Manohla. "Review: 'Black Panther' Shakes
Up the Marvel Universe." *The New York Times.* February 6, 2018. www.n
ytimes.com/2018/02/06/movies/black-panther-review-movie.html;
and, Orr, Christopher. "'Black Panther' Is More Than a Superhero
Movie." *The Atlantic.* February 20, 2018. www.theatlantic.com/enter
tainment/archive/2018/02/black-panther-review/553508/.

4. For example, Carroll, N., "Moderate Moralism," *British Journal of Aesthetics*
 36, no. 3 (1996) and Gaut, B. "The Ethical Criticism of Art." In *Aesthetics
 and Ethics,* edited by Levinson, J. (Cambridge: Cambridge University
 Press, 1998); Booth, W. "Why Banning Ethical Criticism is a Serious
 Mistake," *Philosophy and Literature* 22 (1998).
5. Eaton, A. W., A. W. "Robust Immoralism." The Journal of Aesthetics and
 Art Criticism 70, no. 3 (2012): 281–92.
6. Bartel, Christopher J. "Ordinary Monsters: Ethical Criticism and the
 Lives of Artists." *Contemporary Aesthetics.* August 16, 2019. https://co
 ntempaesthetics.org/newvolume/pages/article.php?articleID=869.
7. Powers, Ann. "The Cruel Truth About Rock And Roll." NPR. July 15,
 2015. www.npr.org/sections/therecord/2015/07/15/422964981/
 the-cruel-truth-about-rock-and-roll.
8. Barnes, Kenyette, and Oronike Odeleve. "R Kelly Protest: #MuteRKelly." R
 Kelly Protest | #MuteRKelly. www.muterkelly.org/whymuterkelly.
9. Liao, S.Y., and Szabó Gendler, T. Pretense and imagination. *Wiley
 Interdisciplinary Reviews: Cognitive Science* 2, no. 1(2011): 86.
10. Schweitzer, N.J., and Michael J. Saks. "The CSI Effect: Popular Fiction
 about Forensic Science Affects the Public's Expectations about Real
 Forensic Science." *Jurimetrics* 47, no. 3 (2007): 357–64.
11. Coates, Ta-Nehisi. "This Is How We Lost to the White Man." *The Atlantic.*
 November 19, 2014. www.theatlantic.com/magazine/archive/2008
 /05/-this-is-how-we-lost-to-the-white-man/306774/.
12. Dyson, Michael Eric. *Is Bill Cosby Right?: or Has the Black Middle Class Lost Its
 Mind?* (Basic Civitas, 2006), 3.
13. "Pilot/Theo's Economic Lesson." *The Cosby Show,* written by Ed.
 Weinberger and Michael Leeson, directed by Jay Sandrich, NBC, 1984.
14. Ibid.
15. Nguyen, C. Thi. "Trust and Sincerity in Art." *Ergo* (forthcoming).

#CANCELEVERYTHING (WE SHOULD PROBABLY SET TWITTER ON FIRE JUST TO BE SAFE)

1. Loughrey, Clarisse. "Aziz Ansari Is the First Man of Asian Descent to Win a Golden Globe for Best Actor in a TV Comedy." *Independent Digital News and Media.* January 8, 2018. www.independent.co.uk/arts-entertai nment/tv/news/golden-globes-2018-aziz-ansari-master-of-none-best-actor-tv-comedy-winners-asian-a8147386.html.

2. Klinenberg, Eric, and Aziz Ansari. *Modern Romance: An Investigation.* (United States: Penguin Press, 2016).

3. Way, Katie. "I Went on a Date with Aziz Ansari. It Turned into the Worst Night of My Life." *Babe.* February 1, 2018. babe.net/2018/01/13/aziz -ansari-28355.

4. Flanagan, Caitlin. "The Humiliation of Aziz Ansari." *The Atlantic.* February 26, 2018. www.theatlantic.com/entertainment/archive /2018/01/the-humiliation-of-aziz-ansari/550541/.

5. North, Anna. "The Aziz Ansari Story Is Ordinary. That's Why We Have to Talk about It." *Vox.* January 16, 2018, www.vox.com/identities/2018 /1/16/16894722/aziz-ansari-grace-babe-me-too.

6. Bunch, Sonny. "Opinion | Babe's Aziz Ansari Piece Was a Gift to Anyone Who Wants to Derail #MeToo." *The Washington Post.* January 15, 2018. www.washingtonpost.com/news/act-four/wp/2018/01/15/babes -aziz-ansari-piece-was-a-gift-to-anyone-who-wants-to-derail-metoo/.

7. Thomas, Megan. "Aziz Ansari Responds to Sexual Assault Claim." *Cable News Network.* January 16, 2018. www.cnn.com/2018/01/15/enterta inment/aziz-ansari-responds/index.html?iid=EL.

8. Bromwich, Jonah Engel. "Everyone Is Canceled." *The New York Times.* June 28, 2018. https://www.nytimes.com/2018/06/28/style/is-it-can celed.html.

9. Ross, Loretta. "I'm a Black Feminist. I Think Call-Out Culture Is Toxic." *The New York Times.* August 17, 2019. www.nytimes.com/2019 /08/17/opinion/sunday/cancel-culture-call-out.html.

10. Anderson, Benedict R. OG. *Imagined Communities: Reflections on the Origin and Spread of Nationalism* (London: Verso, 2016).

11. See: Nwanevu, Osita. "The 'Cancel Culture' Con." *The New Republic.* September 23, 2019. https://newrepublic.com/article/155141/ cancel-culture-con-dave-chappelle-shane-gillis; Ellis, Emma Grey.

"Concerning Consent, Chappelle, and Canceling Cancel Culture." *Wired*. *Conde Nast*. Accessed May 9, 2020. https://www.wired.com/story/canceling-cancel-culture/; Yar, Sanam, and Jonah Engel Bromwich. "Tales From the Teenage Cancel Culture." *The New York Times*. October 31, 2019. https://www.nytimes.com/2019/10/31/style/cancel-culture.html.

12. News, ABC. "NEW: James Gunn Apologizes for Past Tweets: 'I Understand and Accept the Business Decisions Taken Today … I Take Full Responsibility for the Way I Conducted Myself Then. All I Can Do Now, beyond Offering My Sincere and Heartfelt Regret, Is to Be the Best Human Being I Can Be." Pic.twitter.com/YUMfHYGv85." *Twitter*. July 20, 2018. twitter.com/ABC/status/1020413804071596032.

13. Bishop, Bryan. "James Gunn Fired from Guardians of the Galaxy 3 over Offensive Tweets." *The Verge*. July 20, 2018. www.theverge.com/2018/7/20/17596452/guardians-of-the-galaxy-marvel-james-gunn-fired-pedophile-tweets-mike-cernovich.

14. See Placido, Dani Di. "What We Can Learn From The Firing of James Gunn." *Forbes Magazine*. July 26, 2018. www.forbes.com/sites/danidiplacido/2018/07/26/what-we-can-learn-from-the-firing-of-james-gunn//#2c652e823559; screenrant.com/james-gunn-fired-disney-thoughts/; Leadbeater, Alex. "Our Thoughts On James Gunn's Firing." *ScreenRant*. August 10, 2018. screenrant.com/james-gunn-fired-disney-thoughts/.; and, Abad-Santos, Alex. "Disney Has Fired Guardians of the Galaxy Director James Gunn over Old, Gross Tweets." *Vox*. July 20, 2018. www.vox.com/2018/7/20/17596506/disney-fired-james-gunn-guardians.

15. Gay, Roxane. "Louis C.K. and Men Who Think Justice Takes as Long as They Want It To." *The New York Times*. August 29, 2018. www.nytimes.com/2018/08/29/opinion/louis-ck-comeback-justice.html.

16. Hess, Amanda. "Louis C.K. Slithers Back, Whether We're Ready or Not." *The New York Times*. August 30, 2018. www.nytimes.com/2018/08/30/arts/television/louis-ck-returns-metoo.html.

17. "Louis C.K. to Keep Saying the Wrong Things in Comeback Tour." *South China Morning Post*. November 19, 2019. www.scmp.com/lifestyle/entertainment/article/3038367/louis-cks-comeback-tour-post-metoo-performance-not-looking.

18. McDermott, John. "Those People We Tried to Cancel? They're All Hanging Out Together." *The New York Times*. November 2, 2019. www.n ytimes.com/2019/11/02/style/what-is-cancel-culture.html.

19. Fry, Madeline. "How Disney Was Wrong, and Then Right, about 'Guardians of the Galaxy' Director James Gunn." *Washington Examiner*. May 17, 2019. https://www.washingtonexaminer.com/opinion/ho w-disney-was-wrong-and-then-right-about-guardians-of-the-galaxy -director-james-gunn.

20. Gabielkov, Maksym, et al. "Social Clicks." *Proceedings of the 2016 ACM SIGMETRICS International Conference on Measurement and Modeling of Computer Science* – SIGMETRICS 16, 2016, doi:10.1145/2896377.2901462. 2

21. Romano, Aja. "Why We Can't Stop Fighting about Cancel Culture." *Vox*. December 30, 2019. www.vox.com/culture/2019/12/30/2087 9720/what-is-cancel-culture-explained-history-debate.

22. Casey, Michael. "Want Your Tweets to Go Viral? This Website Can Help." *CBS News*. February 16, 2015. www.cbsnews.com/news/want -your-tweets-to-go-viral-this-website-can-help/.

23. Here is a tool that can show you how likely your prose is to be retweeted: Tan, Chenhao. *Want to Be Retweeted More?* – Home. chenhaot.com /retweetedmore/.

24. Tosi, Justin, and Brandon Warmke. "Moral Grandstanding." *Philosophy & Public Affairs* 44, no. 3 (2016): 199. doi:10.1111/papa.12075.

25. Ibid, 201.

26. Ibid, 203–205.

27. Ibid, 206.

28. Ibid.

29. Ibid, 207–208.

30. Ibid, 210.

31. Eppolito, Sophia. "Here's What Matt Damon Said about #MeToo, and the Backlash That Followed - The Boston Globe." *BostonGlobe.com*. December 19, 2017. https://www.bostonglobe.com/arts/2017/12 /19/here-what-matt-damon-said-about-metoo-and-backlash-that- followed/PNOjcVddMV9rQ13eqsDm4I/story.html.

32. Tosi and Warmke, 212.

33. Levy, Neil. "Virtue Signalling Is Virtuous." *Synthese*, 2020. https://doi .org/10.1007/s11229-020-02653-9.

34. Ronson, Jon. "How One Stupid Tweet Blew Up Justine Sacco's Life." *The New York Times*. February 12, 2015. https://www.nytimes.com/2015/02/15/magazine/how-one-stupid-tweet-ruined-justine-saccos-life.html.

AESTHETIC LIVES AS ETHICAL LIVES

1. Williams, Bernard. *Moral Luck*. British First edition (Cambridge: Cambridge University Press, 1981), 22–23.
2. Ibid, 24.
3. Manne, Kate. "Internalism About Reasons: Sad but True?" *Philosophical Studies* 167, no. 1 (2014): 89–117, 91. https://doi.org/10.1007/s11098-013-0234-3.
4. Ibid, 92.
5. Callcut, Daniel. "Living the Life Authentic: Bernard Williams on Paul Gauguin – Daniel Callcut | Aeon Essays." *Aeon*. n.d. Accessed July 5, 2020. https://aeon.co/essays/living-the-life-authentic-bernard-williams-on-paul-gauguin.
6. Williams, 34.
7. Chiang, Ted. "The Lifecycle of Software Objects." In *Exhalation: Stories*. First edition (New York: Knopf, 2019), 91.
8. Paul, L.A. *Transformative Experience* (Oxford: Oxford University Press, 2014), 1–4.
9. See Nguyen, C. T. Autonomy and Aesthetic Engagement. *Mind*. (forthcoming). https://doi.org/10.1093/mind/fzz054; thanks also to Matthew Strohl for discussions on the value of aesthetic difficulty.
10. Cross, A. Obligations to Artworks as Duties of Love. *Estetika: The European Journal of Aesthetics* 54, no. 1 (2017): 85–101, 95–99. https://doi.org/10.33134/eeja.157.
11. See https://potterheadrunning.org/
12. Special thanks to Kimba McIntosh, Sara Rue, Kristin Tomalavage, and Sue Buhagiar for sharing their experiences as runners and fans of Harry Potter.
13. "Addressing J.K. Rowling's Recent Statements." *The-Leaky-Cauldron.Org* (blog). July 1, 2020. http://www.the-leaky-cauldron.org/2020/07/01/addressing-j-k-rowlings-recent-statements/.

14. Pes, Javier. "How Curators Are Addressing Gauguin's Dark Side in a New Show at the National Gallery in London." *artnet News*. October 10, 2019. https://news.artnet.com/exhibitions/gauguin-metoo-national -gallery-1672810.

15. Mendelsohn, Meredith. "Why Is the Art World Divided over Gauguin's Legacy?" *Artsy*. August 3, 2017. https://www.artsy.net/article/artsy -editorial-art-divided-gauguins-legacy.

16. Vercoe, Caroline. "I Am My Other, I Am My Self: Encounters with Gauguin in Polynesia." *Australian and New Zealand Journal of Art* 13, no. 1 (January 2013): 104–25, 112. https://doi.org/10.1080/14434318 .2013.11432645.

"(19) Mark Harris on Twitter: 'SNL Reversing Its Decision to Hire Shane Gillis Isn't a Triumph of Cancel Culture or Political Correctness or Whatever Else Idiots Will Label It. It Is the Swift and Appropriate Rectification of a Mistake.'/Twitter." 2019. *Twitter*. September 16. https://twitter.com/markharrisnyc/status/1173699700882645002.

Adams, Thelma. n.d. "Is It Any Wonder, Woman? The Latest Comic Book Movie Has Estrogen! | Observer." Accessed May 9, 2020. https://observer.com/2017/06/wonder-woman-movie-review-gal-gadot/.

Addressing J.K. Rowling's Recent Statements. 2020. *The-Leaky-Cauldron.Org (blog)*. July 1. http://www.the-leaky-cauldron.org/2020/07/01/addressing-j-k-rowlings-recent-statements/.

Aesthetics for Birds, Eva Dadlez, Carol Hay, David Heti, Shen-yi Liao, Kate Manne, Stephanie Patridge, Matthew Strohl, and Mary Beth Willard. 2017. "Artworld Roundtable: The Art of Immoral Artists." Aesthetics for Birds (blog). November 22. https://aestheticsforbirds.com/2017/11/22/artworld-roundtable-the-art-of-immoral-artists/.

Aesthetics for Birds, Eva Dadlez, David Heti, Shen-yi Liao, Stephanie Patridge, Matthew Strohl, and Mary Beth Willard. 2018. "Can We Separate the Art from the Artist?" Aesthetics for Birds (blog). December 6. https://aestheticsforbirds.com/2018/12/06/can-we-separate-the-art-from-the-artist/.

Anderson, Benedict. 2016. *Imagined Communities: Reflections on the Origin and Spread of Nationalism*. Revised edition. London: Verso.

Anderson, Elizabeth. 2012. "Epistemic Justice as a Virtue of Social Institutions." *Social Epistemology* 26 (2): 163–73. https://doi.org/10.1080/02691728.2011.652211.

Anderson, James C., and Jeffrey T. Dean. 1998. "Moderate Autonomism." *The British Journal of Aesthetics* 38 (2): 150–67.

Asmelash, Leah. 2019. "Why 'cancel culture' Doesn't Always Work - CNN." CNN. September 21. https://www.cnn.com/2019/09/21/entertain ment/cancel-culture-explainer-trnd/index.html.

Bartel, Christopher. 2019. "Ordinary Monsters: Ethical Criticism and the Lives of Artists." August. https://www.contempaesthetics.org/newvol ume/pages/article.php?articleID=869.

BBC News. 2019. "Taylor Swift Opens up about Being 'Cancelled'." August 9, sec. Newsbeat. https://www.bbc.com/news/newsbeat-49289430.

Bennett, Anita, and Anita Bennett. 2019. "Roseanne Barr Details Comeback Plan And Bashes Sara Gilbert Over Firing." Deadline (blog). September 17. https://deadline.com/2019/09/roseanne-barr-details-comeback-plan-and-bashes-sara-gilbert-over-firing-1202736639/.

"Bill Cosby: A 50-Year Chronicle of Accusations and Accomplishments - Los Angeles Times." n.d. Accessed May 9, 2020. https://www.latimes.com/ entertainment/la-et-bill-cosby-timeline-htmlstory.html.

Bloom, Paul. 2017. "The Case Against Empathy." Interview by Sean Illing, January 19. https://www.vox.com/conversations/2017/1/19/142662 30/empathy-morality-ethics-psychology-compassion-paul-bloom.

Broder, John M., and Nick Madigan. 2005a. "Michael Jackson Cleared After 14-Week Child Molesting Trial." The New York Times. June 14, sec. U.S. https ://www.nytimes.com/2005/06/14/us/michael-jackson-cleared-after -14week-child-molesting-trial.html.

Bromwich, Jonah Engel. 2018. "Everyone Is Canceled." The New York Times. June 28, sec. Style. https://www.nytimes.com/2018/06/28/style/is-i t-canceled.html.

Budolfson, Mark Bryant. 2019. "The Inefficacy Objection to Consequentialism and the Problem with the Expected Consequences Response." Philosophical Studies 176 (7): 1711–24. https://doi.org/10.1 007/s11098-018-1087-6.

Callcut, Daniel. n.d. "Living the Life Authentic: Bernard Williams on Paul Gauguin – Daniel Callcut | Aeon Essays." Aeon. Accessed July 5, 2020. https://aeon.co/essays/living-the-life-authentic-bernard-williams-on -paul-gauguin.

Carroll, Noel. 1996. "Moderate Moralism." The British Journal of Aesthetics 36 (3): 223–39.

Chiang, Ted. 2019. "The Lifecycle of Software Objects." In Exhalation: Stories, 1st ed. New York: Knopf.

CNN, Lisa Respers France. 2018. "Dylan Farrow Details Alleged Abuse by Woody Allen in Her First Televised Interview." CNN. January 18. https://www.cnn.com/2018/01/18/entertainment/dylan-farrow-woody-allen-interview/index.html.

CNN, Megan Thomas. 2018. "Aziz Ansari Responds to Sexual Assault Claim." CNN. January 18. https://www.cnn.com/2018/01/15/entertainment/aziz-ansari-responds/index.html.

Coates, Ta-Nehisi. 2008: "This Is How We Lost to the White Man." The Atlantic. May 1. https://www.theatlantic.com/magazine/archive/2008/05/-this-is-how-we-lost-to-the-white-man/306774/.

Cross, A. 2017. "Obligations to Artworks as Duties of Love." Estetika: The European Journal of Aesthetics 54 (1): 85–101. doi: 10.33134/eeja.157

Dargis, Manohla. 2018. "Review: 'Black Panther' Shakes Up the Marvel Universe." The New York Times. February 6, sec. Movies. https://www.nytimes.com/2018/02/06/movies/black-panther-review-movie.html.

Dederer, Claire. 2017. "What Do We Do with the Art of Monstrous Men?" The Paris Review (blog). November 20. https://www.theparisreview.org/blog/2017/11/20/art-monstrous-men/.

Dubner, Stephen. n.d. "Do Boycotts Work?" Accessed May 10, 2020. https://freakonomics.com/podcast/do-boycotts-work-a-new-freakonomics-radio-podcast/.

Dwyer, Colin. n.d. "The Harvey Weinstein Trial: A Brief Timeline Of How We Got Here." NPR.Org. Accessed May 9, 2020. https://www.npr.org/2020/01/22/798222176/the-harvey-weinstein-trial-a-brief-timeline-of-how-we-got-here.

Dyson, Michael Eric. 2006. Is Bill Cosby Right?: Or Has the Black Middle Class Lost Its Mind? First Printing edition. New York: Civitas Books.

Eaton, A. W. 2012. "Robust Immoralism." The Journal of Aesthetics and Art Criticism 70 (3): 281–92.

Ellis, Emma Grey. 2019. "Concerning Consent, Chappelle, and Canceling Cancel Culture." Wired. September 8. https://www.wired.com/story/canceling-cancel-culture/.

Farrow, Ronan. 2017. "From Aggressive Overtures to Sexual Assault: Harvey Weinstein's Accusers Tell Their Stories." The New Yorker. October 23. https://www.newyorker.com/news/news-desk/from-aggressive-overtures-to-sexual-assault-harvey-weinsteins-accusers-tell-their-stories.

Flanagan, Caitlin. 2018. "The Humiliation of Aziz Ansari." *The Atlantic.* January 14. https://www.theatlantic.com/entertainment/archive/2018/01/the-humiliation-of-aziz-ansari/550541/.

Framke, Caroline. 2018. "How the Aziz Ansari Story Deepened a Crucial Divide in the #MeToo Reckoning." *Vox.* January 17. https://www.vox.com/culture/2018/1/17/16897440/aziz-ansari-allegations-babe-me-too.

Fricker, Miranda. 2007. *Epistemic Injustice: Power and the Ethics of Knowing.* New York: Oxford University Press.

Fry, Madelein. 2019. "Don't Frame Shane Gillis as the Victim of 'Cancel Culture.'" *Washington Examiner.* September 7. https://www.washingtonexaminer.com/opinion/dont-frame-shane-gillis-as-the-victim-of-cancel-culture.

Fry, Madeline. 2019. "How Disney Was Wrong, and Then Right, about 'Guardians Of The Galaxy' Director James Gunn." *Washington Examiner.* May 17. https://www.washingtonexaminer.com/opinion/how-disney-was-wrong-and-then-right-about-guardians-of-the-galaxy-director-james-gunn.

Geimer, Samantha, Lawrence Silver, and Judith Newman. 2014. *The Girl: A Life in the Shadow of Roman Polanski.* London: Simon and Schuster.

Greenburg, Zack O'Malley. 2017. *Michael Jackson, Inc.: The Rise, Fall, and Rebirth of a Billion-Dollar Empire.* New York: Atria Books.

Greenburg, Zack O'Malley. 2018. "Michael Jackson At 60: The King Of Pop By The Numbers." *Forbes.* August 28. https://www.forbes.com/sites/zackomalleygreenburg/2018/08/29/michael-jackson-at-60-the-king-of-pop-by-the-numbers/.

Hagi, Sarah. 2019. "Cancel Culture Is Not Real—At Least Not in the Way You Think | Time." *Time.* November 21. https://time.com/5735403/cancel-culture-is-not-real/.

Hamilton, Jack. 2019. "There's No Separating Michael Jackson's Music From His Obsession With Children." *Slate Magazine.* February 27. https://slate.com/culture/2019/02/michael-jackson-music-children-obsession-separating-art-from-artist.html.

Harris, Hunter. 2018. "Two Women Describe Louis C.K.'s 'Uncomfortable' Comedy Cellar Set." *Vulture.* August 29. https://www.vulture.com/2018/08/louis-ck-comedy-cellar-women-describe-rape-whistle-joke.html.

Hawksley, Lucinda. 2016. "Culture - The Forgotten Wife of Charles Dickens." *BBC*. May 19. www.bbc.com/culture/story/20160519-the-forgotten-w ife-of-charles-dickens.

Herzog, Katie. 2019. "Cancel Culture: What Exactly Is This Thing?" *The Stranger*. September 17. https://www.thestranger.com/slog/2019/09 /17/41416013/cancel-culture-what-exactly-is-this-thing.

Holland, Dean. 2018. "Don't Let the Good Life Pass You By." *The Good Place*. NBC.

Houck, Brenna. 2018. "Why the World Is Hating on Plastic Straws Right Now." *Eater*. July 12. https://www.eater.com/2018/7/12/17555880/ plastic-straws-environment-pollution-banned-alternatives-ocean-sea-tu rtle-viral-video.

"How Spotify, Apple Music, Can Pay Musicians More-Commentary." 2018. January 26. https://www.cnbc.com/2018/01/26/how-spotify-apple- music-can-pay-musicians-more-commentary.html.

Ivanhoe, Philip J., and Bryan William Van Norden. 2007. *Readings in Classical Chinese Philosophy*. Indianapolis: Hackett Publ.

Kearl, Holly. 2018. "The Facts Behind the #Metoo Movement: A National Study on Sexual Harassment and Assault." February, 41. http://www .stopstreetharassment.org/wp-content/uploads/2018/01/Full-Re port-2018-National-Study-on-Sexual-Harassment-and-Assault.pdf

de Leon, J.M. 2017. "That Thing Called 'Beausage'." *The Accidental Randonneur* (blog). March 14. https://accidentalrandonneur.wordpress.com/2017 /03/15/that-thing-called-beausage/.

Lepora, Chiara, and Robert E. Goodin. n.d. Complicity and Its Conceptual Cousins. On Complicity and Compromise. Oxford University Press. Accessed May 10, 2020. https://www.oxfordscholarship.com/view /10.1093/acprof:oso/9780199677900.001.0001/acprof-9780199 677900-chapter-3.

Levinson, Jerrold. 2010. "Artistic Worth and Personal Taste." *The Journal of Aesthetics and Art Criticism* 68 (3): 225–33. https://doi.org/10.1111/j .1540-6245.2010.01414.x.

Levy, Neil. 2020. "Virtue Signalling Is Virtuous." *Synthese*. April. https://doi .org/10.1007/s11229-020-02653-9.

Livingstone, Josephine. 2017. "Wonder Woman Is Propaganda." *The New Republic*. June 6. https://newrepublic.com/article/143100/wonder -woman-propaganda.

Lopes, Dominic McIver. 2018. *Being for Beauty: Aesthetic Agency and Value.* 1st edition. Oxford: Oxford University Press.

Loughrey, Clarisse. 2018. "Aziz Ansari Is the First Man of Asian Descent to Win a Golden Globe for Best Actor in a TV Comedy." *The Independent.* January 8. http://www.independent.co.uk/arts-entertainment/tv/news/golden-globes-2018-aziz-ansari-master-of-none-best-actor-tv-comedy-winners-asian-a8147386.html.

Maddaus, Gene, and Gene Maddaus. 2020. "Michael Jackson Accusers' Lawsuits Revived by Appeals Court." *Variety (blog).* January 3. https://variety.com/2020/biz/news/michael-jackson-appeals-court-james-safechuck-wade-robson-1203456204/.

Manne, Kate. 2014. "Internalism About Reasons: Sad but True?" *Philosophical Studies* 167 (1): 89–117. doi: 10.1007/s11098-013-0234-3.

McDermott, John. 2019. "Those People We Tried to Cancel? They're All Hanging Out Together." *The New York Times.* November 2, sec. Style. https://www.nytimes.com/2019/11/02/style/what-is-cancel-culture.html.

McDonnell, Mary-Hunter, and Brayden King. 2013. *Keeping Up Appearances: Reputational Threat and Impression Management after Social Movement Boycotts.* SSRN Scholarly Paper ID 2227090. Rochester, NY: Social Science Research Network. https://doi.org/10.2139/ssrn.2227090.

Mitchell, Victoria Coren. 2013. "Roman Polanski and the Sin of Simplification | Victoria Coren Mitchell." *The Guardian.* September 28, sec. Opinion. https://www.theguardian.com/commentisfree/2013/sep/29/roman-polanski-samantha-geimer.

Nayeri, Farah. 2019. "Is It Time Gauguin Got Canceled?" *The New York Times.* November 18, sec. Arts. https://www.nytimes.com/2019/11/18/arts/design/gauguin-national-gallery-london.html.

Nehamas, Alexander. 2010. *Only a Promise of Happiness: The Place of Beauty in a World of Art.* New edition. Princeton University Press.

News, Deseret. 2003. "Victim Distances Self from Polanski, Assault." *Deseret News.* February 25. https://www.deseret.com/2003/2/25/19706230/victim-distances-self-from-polanski-assault.

Nguyen, C. Thi. 2020. *Games: Agency As Art.* New York: Oxford University Press.

Nguyen, C. Thi. forthcoming. "Trust and Sincerity in Art." *Ergo: An Open Access Journal of Philosophy.*

Nguyen, C. Thi. "Autonomy and Aesthetic Engagement." *Mind.* https://doi.org/10.1093/mind/fzz054.

Nwanevu, Osita. 2019. "The 'Cancel Culture' Con." *The New Republic*. September 23. https://newrepublic.com/article/155141/cancel-cult ure-con-dave-chappelle-shane-gillis.

Orr, Christopher. 2018. "'Black Panther' Review: The Political Visions of Ryan Coogler's Film - The Atlantic." *The Atlantic*. February 16. https:// www.theatlantic.com/entertainment/archive/2018/02/black-panther -review/553508/.

Parfit, Derek. 1986. *Reasons and Persons*. Oxford: Oxford University Press.

Paul, L.A. 2014. *Transformative Experience*. Oxford: Oxford University Press.

Pes, Javier. 2019. "How Curators Are Addressing Gauguin's Dark Side in a New Show at the National Gallery in London." *artnet News*. October 10. https://news.artnet.com/exhibitions/gauguin-metoo-national-gallery -1672810.

"Pilot/Theo's Economic Lesson." 1984. *The Cosby Show*, written by Ed. Weinberger and Michael Leeson, directed by Jay Sandrich, NBC.

Planty, Michael, Lynn Langton, Christopher Krebs, Marcus Berzofsky, and Hope Smiley-McDonald. 2013. *Female Victims of Sexual Violence, 1994–2010*: (528212013–001). American Psychological Association. https://doi.org /10.1037/e528212013-001.

Posner, Richard A. 1997. "Against Ethical Criticism." *Philosophy and Literature* 21 (1): 1–27. https://doi.org/10.1353/phl.1997.0010.

Powers, Ann. 2015. "The Cruel Truth About Rock And Roll." *NPR.Org*. July 15. https://www.npr.org/sections/therecord/2015/07/15/42296 4981/the-cruel-truth-about-rock-and-roll.

Radzik, Linda. 2017. "Boycotts and the Social Enforcement of Justice." *Social Philosophy and Policy* 34 (1): 102–22. https://doi.org/10.1017/S02650 5251700005X.

"Review: 'Black Panther' Shakes Up the Marvel Universe - The New York Times." 2018 Accessed May 9, 2020. https://www.nytimes.com/2018 /02/06/movies/black-panther-review-movie.html.

Riggle, Nicholas. 2013. "Levinson on the Aesthetic Ideal." *The Journal of Aesthetics and Art Criticism* 71 (3): 277–81.

Riggle, Nicholas. 2017. *On Being Awesome: A Unified Theory of How Not to Suck*. New York: Penguin Books.

"Roman Polanski: The Truth about His Notorious Sex Crime." 2008. *The Independent*. October 5. http://www.independent.co.uk/news/people

/profiles/roman-polanski-the-truth-about-his-notorious-sex-crime-949106.html.

Rueb, Emily S., and Derrick Bryson Taylor. 2019. "Obama on Call-Out Culture: 'That's Not Activism.'" *The New York Times*. October 31, sec. U.S. https://www.nytimes.com/2019/10/31/us/politics/obama-woke-cancel-culture.html.

"Samantha Geimer Tells Her Side of Story in Roman Polanski Case." 2013. *Los Angeles Times*. September 16. https://www.latimes.com/entertainment/la-xpm-2013-sep-16-la-et-jc-geimer-book-20130916-story.html.

Schweitzer, N.J. and Michael J. Saks. 2007. "The CSI Effect: Popular Fiction About Forensic Science Affects The Public's Expectations About Real Forensic Science." *Jurimetrics* 47 (3): 357–364. .

Sen, Sankar, Zeynep Gürhan-Canli, and Vicki Morwitz. 2001. "Withholding Consumption: A Social Dilemma Perspective on Consumer Boycotts." *Journal of Consumer Research* 28 (3): 399–417. https://doi.org/10.1086/323729.

Sibley, Frank. 1959. "Aesthetic Concepts." *Philosophical Review* 68 (4): 421–450. https://doi.org/10.2307/2182490.

Silman, Anna. 2019. "Aziz Ansari's Comeback Show Was a Lot to Process." *The Cut*. February 8. https://www.thecut.com/2019/02/aziz-ansari-road-to-nowhere-show-review.html.

Stelter, Brian. 2018. "Babe Editor Stands by Aziz Ansari Story." *CNN Money*. January 15. https://money.cnn.com/2018/01/15/media/aziz-ansari-babe-editor-interview/index.html.

Strohl, Matthew. 2018. *Aesthetic Akrasia*.

Tannsjo, Torbjorn. 1989. "The Morality of Collective Actions." *The Philosophical Quarterly* (1950-) 39 (155): 221–28. https://doi.org/10.2307/2219640.

"The New Wonder Woman Is OK with Men | Movie Review | Chicago Reader." n.d. Accessed May 9, 2020. https://www.chicagoreader.com/chicago/wonder-woman-dc-comics-patty-jenkins-gal-gadot/Content?oid=26903719.

"Timeline: Bill Cosby: A 50-Year Chronicle of Accusations and Accomplishments." 2018. *Los Angeles Times*. September 25. https://www.latimes.com/entertainment/la-et-bill-cosby-timeline-htmlstory.html.

Tosi, Justin, and Brandon Warmke. 2016. "Moral Grandstanding." *Philosophy and Public Affairs* 44 (3): 197–217. https://doi.org/10.1111/papa.12075.

Vercoe, Caroline. 2013. "I Am My Other, I Am My Self: Encounters with Gauguin in Polynesia." *Australian and New Zealand Journal of Art* 13 (1): 104–25. https://doi.org/10.1080/14434318.2013.11432645.

Weinstock, Daniel. 2019. "Dissidents and Innocents: Hard Cases for a Political Philosophy of Boycotts." *Journal of Applied Philosophy* 36 (4): 560–74. https://doi.org/10.1111/japp.12304.

Williams, Bernard. 1981. Moral Luck. British First edition. Cambridge: Cambridge University Press.

Wolf, Susan. 1982. "Moral Saints." *The Journal of Philosophy*. August 1. https://doi.org/10.2307/2026228.

Woolf, Jenny. 2010. "Lewis Carroll's Shifting Reputation." *Smithsonian Magazine*. April. https://www.smithsonianmag.com/arts-culture/lewis-carrolls-shifting-reputation-9432378/.

Yap, Audrey S. 2017. "Credibility Excess and the Social Imaginary in Cases of Sexual Assault." *Feminist Philosophy Quarterly* 3 (4). https://doi.org/10.5206/fpq/2017.4.1.

Yar, Sanam, and Jonah Engel Bromwich. 2019. "Tales From the Teenage Cancel Culture." *The New York Times*. October 31, sec. Style. https://www.nytimes.com/2019/10/31/style/cancel-culture.html.

Index